IMAGES
of America

CHENANGO CANAL
THE MILLION DOLLAR DITCH

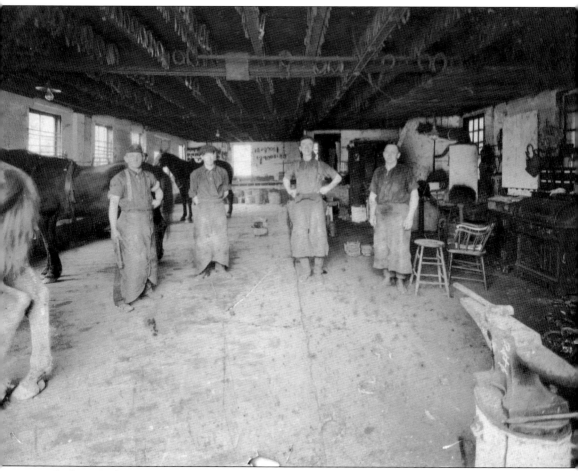

Blacksmith shops like this one in Clinton, New York, were important during the construction and operation of the Chenango Canal. All lock hardware at the time of construction was made by blacksmiths, as there were no factories to do so. Horses and mules also relied on blacksmiths for their iron shoes. (Author's collection.)

IMAGES
of *America*

CHENANGO CANAL
THE MILLION DOLLAR DITCH

Wade Allen Lallier

ARCADIA
PUBLISHING

Published by Arcadia Publishing
Charleston, South Carolina

Printed in the United States of America

Library of Congress Control Number: 2016953983

For all general information, please contact Arcadia Publishing:
Telephone 843-853-2070
Fax 843-853-0044
E-mail sales@arcadiapublishing.com
For customer service and orders:
Toll-Free 1-888-313-2665

Visit us on the Internet at www.arcadiapublishing.com

To Donna, Megan, and Travis, who were there from the start, and to Mom and Dad, who always believed in me

CONTENTS

ACKNOWLEDGMENTS

I am grateful to the following individuals and organizations who contributed their time and resources in the collection of information and photographs relating to the Chenango Canal: Brian Howard, curator of the Oneida County Historical Society; Rome Historical Society; Patrick McKnight, Steamtown National Historic Site; Lori Chien and Jervis Public Library; Erie Canal Museum, Syracuse; Canastota Canal Museum; Richard Williams, Village of Clinton Historian; Robert Tegart and Jerry Semchencko, Clinton Historical Society; Christian Goodwillie and Katherine Collett, Hamilton College Library Special Collections; Judy Engle, Limestone Ridge Historical Society; Helen Nower; Town of Madison Historical Society; Colgate University Library Special Collections; Mary Messire, Eaton Old Town Museum; Mike Kicinski, Quincy Square Museum; Sherburne Historic Park Society and Museum; Patricia Evans, Chenango County Historian's Office; Sarah Mahan, Chenango County Historical Society; Vicky House, Town of Oxford Historian; Fred Lanphear, Oxford Historical Society; John Taibi; Paul and Mary King, and Nancy Bromley, Green Historical Society; Gerald Smith, Broome County historian; Broome County Historical Society; Nebraska State Historical Society; Ruth Mott Foundation; Chicago History Museum; Francis Lallier, Town of Marshall Historical Society; Joan Prindle, Hamilton Historical Commission; Ruth Cosgrove, Kirkland Town Library; Gary Fuess; and Helen Tower Brunet.

Unless otherwise noted, all images are courtesy of the author's personal collection.

Special thanks go to Diane Van Slyke and the Chenango Canal Association for the invaluable contributions; without them, this book would not have been possible.

INTRODUCTION

Before 1836, the people of the Chenango Valley were isolated from the rest of the state by thick woods and hilly terrain. Poor seasonal roads were the only connection with the rest of the state. Railroads were still in their infancy, and there was no stagecoach running through to the valley. People lived a basic frontier life of subsistence farming with a few local mills to produce lumber and flour. With the opening of the prosperous Erie Canal in 1825, people of the Chenango Valley soon wanted to be connected to it with their own canal. In the ensuing canal craze, the Omnibus Canal Bill of 1825 was passed calling for the survey of 17 possible connecting canal routes to the Erie Canal, called laterals. Seven laterals would eventually be constructed, the Chenango Canal through the Chenango Valley was one of these. The proposed 97-mile-long canal would connect the Susquehanna River in Binghamton to the Erie Canal in Utica.

The original survey of the canal by James Geddes, a chief engineer on the Erie, raised questions that the state legislators were leery of. The uncertainty of an adequate water supply at the summit level seemed the most important. The proposed canal would have to rely on artificial reservoirs and miles of feeder canals to supply water to the canal, as there was no natural water supply at the summit—a feat never before successfully done in America. The costs of such a construction were thought to exceed the $1 million budget set by lawmakers. The tolls to be collected were thought to not be enough to cover construction costs and maintenance. To overcome opposition to the canal, advocates organized a committee of representatives from all counties that the canal would pass through to lobby for the construction. The most notable of these men was Reuben Tower from Waterville, New York, who worked nonstop from 1829 until his death in 1832 promoting the canal. Together, canal advocates fought eight years of legislative battles before a bill for the construction was passed on February 23, 1833.

John B. Jervis was selected as chief engineer of the project by William Bouck, state canal commissioner, who had worked with Jervis on the Erie Canal. Jervis faced the challenge of proving that a system of man-made reservoirs and miles of feeders could make the canal work. Starting at the Erie Canal in Utica, the canal would climb to the summit level in Bouckville, employing 76 locks to overcome the rise of 706 feet in just 23 miles. From Bouckville to Binghamton, just 30 locks would take the canal down the following 74 miles. Jervis proved scientifically by ingenious invention that the water system would work. Employing a largely Irish workforce (each man worked for $11 a month), Jervis was able to construct the canal in two years. The canal had been originally budgeted for $1 million; lawmakers had looked at the cost of a comparable section of the Erie Canal (roughly $1 million) as a measure to estimate costs for building the Chenango Canal. Labor costs and rapid inflation plagued the construction, raising the final cost to $2,316,816. The successful construction of a canal with a large number of structures and extensive feeder system led people to call the canal "the best-built canal in New York State."

The canal brought prosperity to all the communities along its banks. New businesses grew around canal towns as the canal transport brought new opportunities. Farm produce, hops, and cider found their way into new storage and forwarding businesses. Men like Alonzo Peck became wealthy by creating docking facilities along the canal. When factories switched from waterpower to steam power, coal became an important cargo on the canal. The Utica textile industry, the blast furnaces of Franklin Springs, and the Maydole Hammer factory all relied on cheap coal transported on the canal.

In its 40 years of operation, the Chenango Canal never achieved the success of the Erie. Its wood and stone structures became more and more expensive to maintain. The railroads emerged as a reliable, year-round transportation system and began to take most of the canal business. An effort to save the canal was made by extending the waterway to the coalfields in Pennsylvania in 1865. The construction was started but soon ran out of money and was abandoned. New York State finally closed the canal in 1877.

One

Before the Canal

Gov. Dewitt Clinton had envisioned New York State covered by a network of interconnecting canals. The success of the Erie Canal had led all New Yorkers to want a canal of their own, and the people of the Chenango Valley were no exception. In the 1820s, transportation in and out of the Chenango Valley was over poor seasonal roads. There was no stagecoach or train connecting Utica to Binghamton. Without a canal, the people of the valley seemed destined to be cut off from the rest of the state.

Hope for a Chenango Canal came with the passage of an omnibus canal bill in 1825. A survey of a possible canal route through the Chenango Valley was conducted by James Geddes, a chief engineer on the Erie Canal. He thought that a Chenango Canal could be built, but it would not be easy or cheap. The survey also raised important questions that would have to be answered before the lawmakers would support the canal.

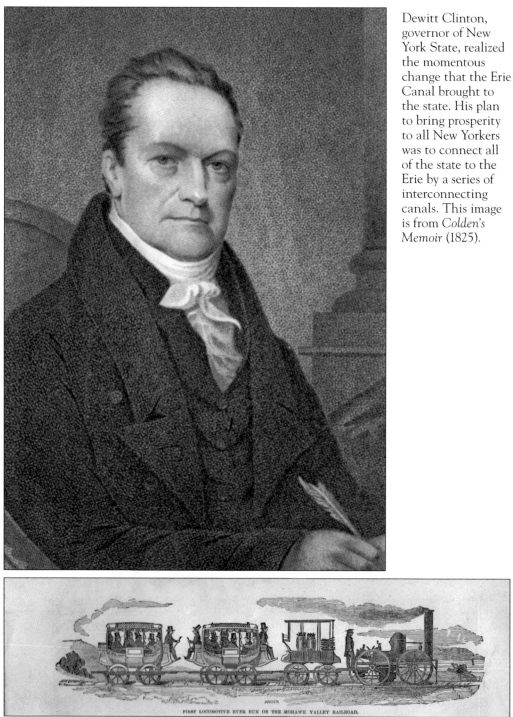

Dewitt Clinton, governor of New York State, realized the momentous change that the Erie Canal brought to the state. His plan to bring prosperity to all New Yorkers was to connect all of the state to the Erie by a series of interconnecting canals. This image is from *Colden's Memoir* (1825).

FIRST LOCOMOTIVE EVER RUN ON THE MOHAWK VALLEY RAILROAD.

This lithograph from *One Hundred Years of Progress* (8172) shows the running of the first train on the Mohawk Railroad. Its locomotive had four fixed wheels that did not allow it to round curves at speed. Rails were made of wood capped with a band of iron, thus prohibiting the shipment of heavy cargo on the cars of the day. (Courtesy of the Clinton Historical Society.)

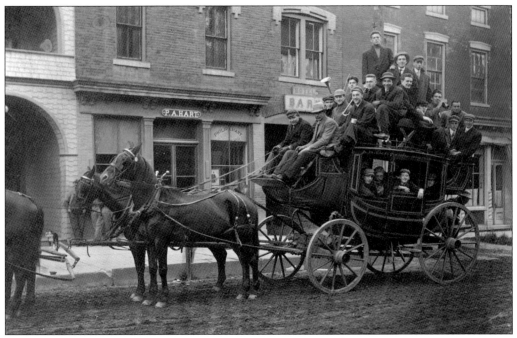

This crowded stagecoach shows how it was not uncommon to have 12 or more passengers on a trip. The men on this stagecoach are probably Hamilton College students who are taxing the capacity of the coach on their way up the short drive to the college on the hill. (Courtesy of the Clinton Historical Society.)

There was no stagecoach route between Binghamton and Utica before 1825. Travel by horse and wagon was over rough seasonal roads. This stagecoach in Clinton, New York, used six horses to pull its load over bumpy roads. A canalboat carrying over 50 tons could be pulled smoothly by just two mules. (Courtesy of the Clinton Historical Society.)

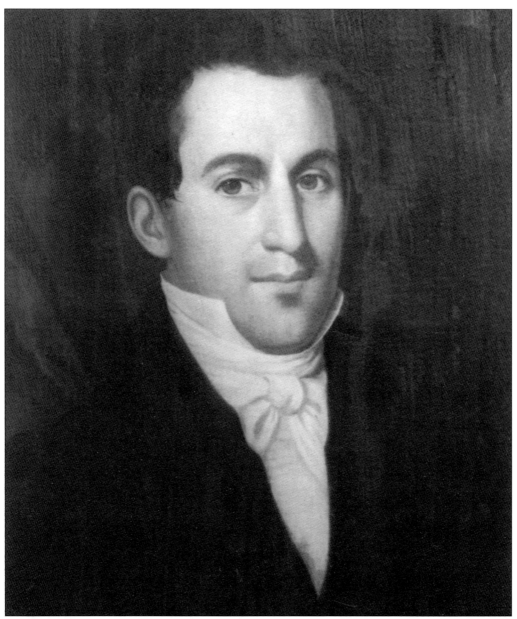

In order to drum up support for a passage of the Chenango Canal bill, a canal committee was formed from prominent men from all the counties that the canal would pass through. The committee sponsored several surveys using prominent engineers of the time trying to prove its justification. Assemblyman Francis Granger and state senator William Maynard worked hard to push the canal bill through. Reuben Tower (pictured) was probably the most important of these lobbyists for the Chenango Canal. He worked relentlessly to promote the canal, going so far as accompanying Holmes Hutchinson on his survey of the canal in 1828. His chief opposition was the controlling Democratic Party, known as the "Albany Regency," who said that the Chenango Canal would never generate enough tolls to support it and that the cost of construction would be too expensive. After eight years of legislative battles, the canal bill was finally passed in 1833. (Courtesy of Helen Tower Brunet.)

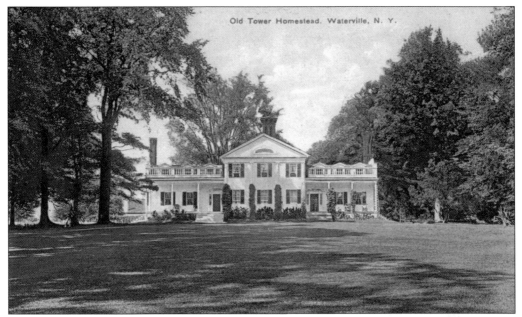

Reuben Tower built this home on a slight rise overlooking the town of Waterville, New York. The original center section had two wings added to it as his fortune and family grew. (Courtesy of Waterville Historical Society.)

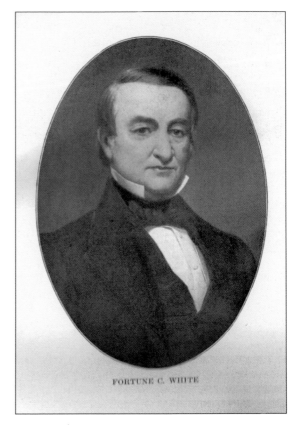

FORTUNE C. WHITE

A grandson of Hugh White and son of Col. Daniel Clark White, Fortune C. White was born July 10, 1787, in Whitestown, New York. He served in two campaigns with the New York State militia in the War of 1812. He later became a prominent lawyer in Oneida County and was a member of the canal committee representing Oneida County with Reuben Tower. This image is from *A History of Oneida County*. (Courtesy of the Clinton Historical Society.)

13

Ammi Doubleday—cousin of Abner Doubleday, who is credited with inventing baseball—was one of the committeemen from Broome County. (Courtesy of the Broome County Library.)

Gaius Butler was a surveyor from Clinton, New York, during the time of Chenango Canal construction. Gaius is pictured with the typical surveying equipment of the time: a surveyors' circumferentor, Jacob staff, measuring chains, and a logbook. The proposed canal would be surveyed six times before the Chenango Canal bill was passed. (Courtesy of the Clinton Historical Society.)

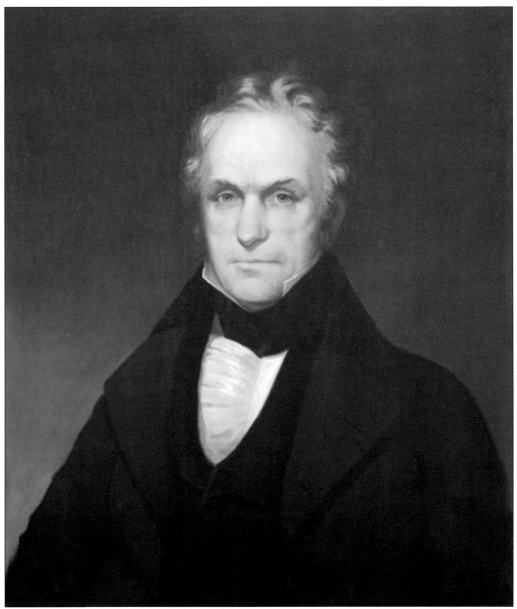

The Chenango Canal committee sponsored several surveys of the canal, employing many of the Erie Canal's top engineers, including Nathan Roberts, in hope that their expertise would sway the government to pass the Chenango Canal bill. Roberts was famous for building the five-lock combine at Lockport. He surveyed the canal in 1827 and agreed with his peers that it could be built. (Courtesy of Canastota Canal Museum.)

AN APPEAL

TO THE

PEOPLE OF THE STATE OF NEW-YORK,

IN FAVOR OF THE CONSTRUCTION OF THE

CHENANGO CANAL,

With Statements and Documents, to prove the claim of that part of the State for
this improvement ; and arguments on the subject of the supply
of water, cost of construction, and revenue.

BY COL. R. TOWER.

Utica :
Dauby & Maynard, Printers, No. 81, Genesee-Street.
1830.

In his widely distributed pamphlet, Reuben Tower argues in length the benefits of the canal. In it, he correctly predicts the depletion of wood supplies and the growing demand for cheap coal, which could only be delivered by the canal. Sadly, Tower died in March 1832 before the Chenango Canal bill was passed.

SPEECH

OF

WILLIAM H. MAYNARD,

ON THE BILL FOR THE CONSTRUCTION OF THE

CHENANGO CANAL.

DELIVERED IN THE
SENATE OF NEW YORK,
February 23 and 24, 1831.

UTICA:
PRESS OF WILLIAM WILLIAMS, GENESEE STREET.
1831.

In 1831, William Maynard presented a lengthy speech promoting the Chenango Canal to the state senate. The speech was given over two days. The published speech echoes much of Reuben Tower's thoughts.

Seen in this image from *Notable Men of New York*, William H. Maynard was an Anti-Masonic state senator from the village of New Hartford in Oneida County. Maynard, along with John Hubbard and Francis Granger, would usher many of the Chenango Canal bills through the state legislature. (Courtesy of the Clinton Historical Society.)

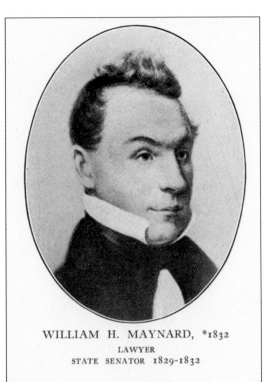

WILLIAM H. MAYNARD, *1832
LAWYER
STATE SENATOR 1829-1832

Francis Granger was a member of the state assembly from 1826 to 1828 and 1830 to 1832. In 1836, he was the unsuccessful Anti-Masonic candidate for vice president. As a leader of the Anti-Masonic Party, Granger used his influence as chairman on the committee on canals to help promote Chenango Canal bills. The Anti-Masonic Party used the canal as part of its party platform to garner votes in the Chenango Valley area. Granger also owned property along the canal route and would benefit from the canal bill passing. (Courtesy of the Library of Congress.)

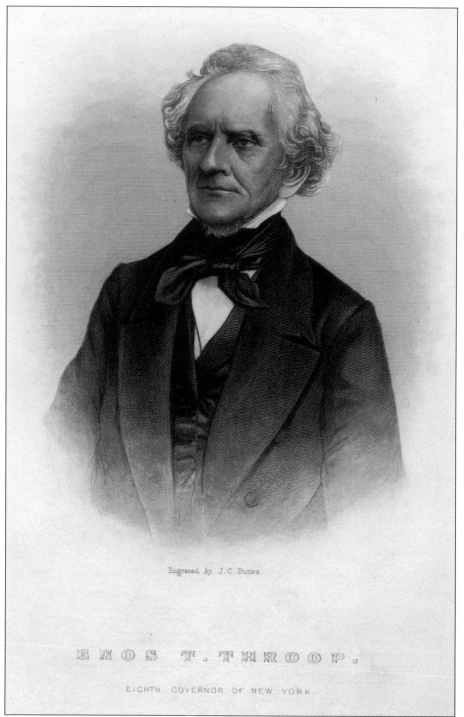

Engraved by J.C.Buttre.

E N O S T. T H R O O P.

EIGHTH GOVERNOR OF NEW YORK.

As New York governor from 1829 to 1832, Enos Throop opposed building the canal and was backed by the Democratic majority. He correctly predicted that the canal would be a financial failure for the state. His canal opposition would eventually lead to his removal from office and replacement by a Chenango Canal advocate. (Courtesy of the Oneida County Historical Society.)

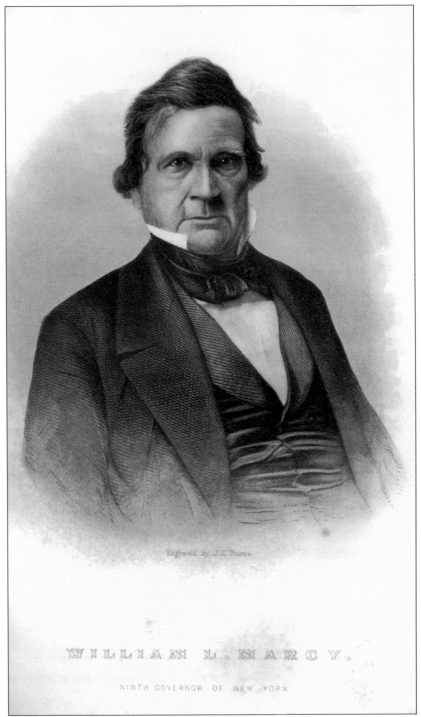

WILLIAM L. MARCY.

NINTH GOVERNOR OF NEW YORK.

The election of Governor Marcy, a canal advocate, in 1833 ensured that the Chenango Canal bill would pass. On February 23, 1833, the act for the construction of the Chenango Canal became law, passed by large majorities in both houses of the legislature. (Courtesy of the Oneida County Historical Society.)

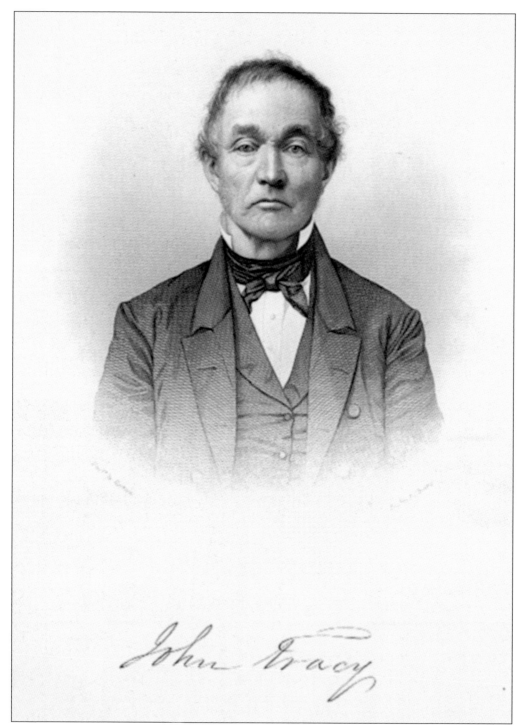

Lt. Gov. John Tracy from the town of Oxford in the Chenango Valley was also a canal advocate. Tracy owned property along the canal route and would gain personally from its construction. His election, along with Marcy's, ensured the passing of the canal bill. This image is from the *History of Chenango and Madison Counties*. (Courtesy of the Town of Madison Historical Society.)

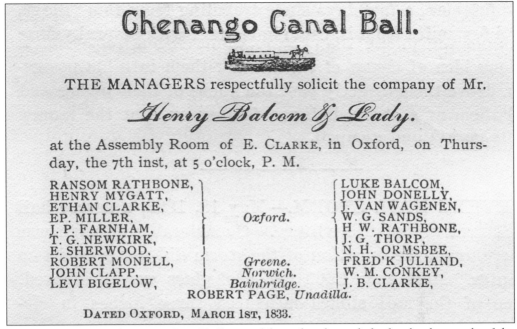

Chenango Canal Ball.

THE MANAGERS respectfully solicit the company of Mr.

Henry Balcom & Lady.

at the Assembly Room of E. CLARKE, in Oxford, on Thursday, the 7th inst, at 5 o'clock, P. M.

RANSOM RATHBONE,		LUKE BALCOM,
HENRY MYGATT,		JOHN DONELLY,
ETHAN CLARKE,		J. VAN WAGENEN,
EP. MILLER,	*Oxford.*	W. G. SANDS,
J. P. FARNHAM,		H W. RATHBONE,
T. G. NEWKIRK,		J. G. THORP,
E. SHERWOOD.		N. H. ORMSBEE,
ROBERT MONELL,	*Greene.*	FRED'K JULIAND,
JOHN CLAPP,	*Norwich.*	W. M. CONKEY,
LEVI BIGELOW,	*Bainbridge.*	J. B. CLARKE,

ROBERT PAGE, *Unadilla.*

DATED OXFORD, MARCH 1ST, 1833.

The passage of the Chenango Canal bill was celebrated with much fanfare by the people of the Chenango Valley. Invitations to a ball in Oxford were sent to all of the area's influential people. This ball on March 1, 1833, was typical of the festivities that occurred along the canal route. (Courtesy of the Oxford Historical Society.)

The Hotchkiss House, in the foreground, was the site of a grand canal ball to celebrate the passing of the canal bill in 1833. (Courtesy of the Oxford Historical Society.)

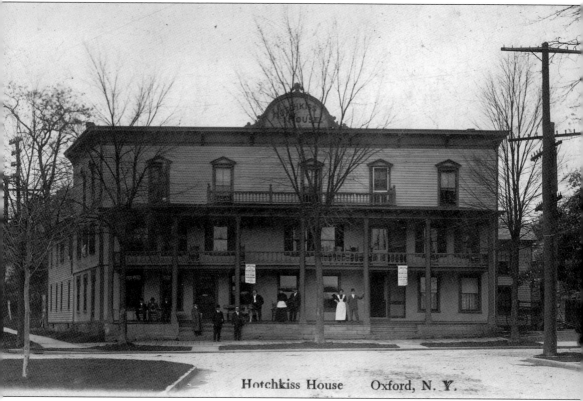

Hotchkiss House Oxford, N. Y.

The Hotchkiss House was the site of the Oxford canal ball, on March 7, 1833, which attracted over 500 people. The gala was typical of the celebration all along the canal. (Courtesy of the Oxford Historical Society.)

Two

The Construction

Future governor William Bouck was, at the time of the construction of the Chenango Canal, the New York State canal commissioner. Bouck selected his friend John B. Jervis of Rome, New York, to be the chief engineer of the canal in 1834. Jervis had an impressive engineering résumé. Starting out as a lowly axeman on a survey crew at the beginning of the Erie Canal construction, Jervis became a protégé of the Erie Canal's chief engineer, Benjamin Wright. Jervis quickly rose through the ranks to become resident engineer on a 50-mile section of the Erie. Jervis left the Erie and went on to be chief engineer on the Delaware and Hudson Canal Company Gravity Railroad and Mohawk & Hudson Railroad and had designed the English-built *Stourbridge Lion*, the first locomotive to run in America.

Jervis's main challenge on the Chenango Canal was to ensure that there would be enough water at the summit level to make the canal work. At the time, there was no way to accurately measure runoff from rainfall in reservoirs. He invented a system combining the use of a rain gauge and a sluice to measure rainfall and runoff. These devices proved scientifically that there would be ample water at the summit to make the canal work. The construction would consist of digging a ditch 4 feet deep, 42 feet wide at the top, 26 feet wide at the bottom, and 97 miles long. Seven reservoirs would have to be built along with the 17 miles of connecting feeders. A total of 116 locks, 19 aqueducts, 52 culverts, and 215 bridges would have to be constructed before the canal could be operational. Once Jervis proved that the canal could work, he did not find the construction anything out of the ordinary. Having worked on two previous canals, he considered the engineering routine. In his memoir, he devotes only a few words to its construction.

Although Jervis did not consider the construction of the canal important work, his professionalism and work ethic can be seen in his dedication to details in the construction. Contractors were given clear and specific instructions for building the various canal structures and prism (the canal itself). Meticulous records were kept, and Jervis corresponded frequently with his principals to make sure the construction went on as planned.

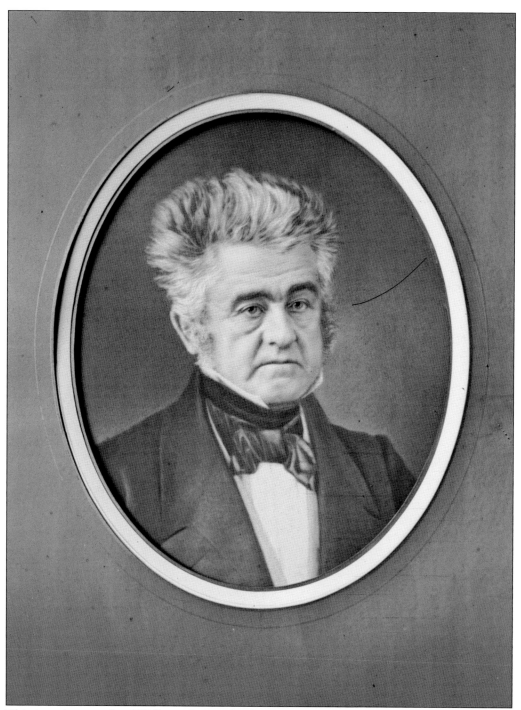

This is a photograph of William C. Bouck, chairman of the New York canal committee. He selected John B. Jervis as the chief engineer for the canal. Jervis was well known for his engineering skills, and his selection for engineer of the Chenango Canal was also aided by the fact that he personally knew three members of the canal commission, including his friend (and future New York governor) Bouck. (Courtesy of the Library of Congress.)

John B. Jervis was a rising star in American engineering in 1833. Jervis had an impressive resume before taking on the job of chief engineer for the Chenango Canal. He had been a section engineer on the Erie Canal, chief engineer of the Delaware and Hudson Canal, and chief engineer on two railroads before taking on the challenges of the Chenango Canal. His major problem in engineering the Chenango Canal was proving that there was enough water at the summit to supply the canal. His invention of a rain gauge and sluice devise proved scientifically that there was an ample supply. (Courtesy of the Jervis Public Library.)

The proposed canal would be 97 miles long, connecting the Erie Canal at Utica to the Susquehanna River at Binghamton. Towns along its length would prosper with its construction.

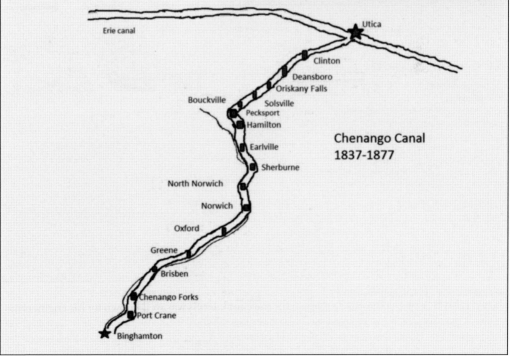

Erie canal

Utica

Clinton
Deansboro
Oriskany Falls
Bouckville
Solsville
Pecksport
Hamilton
Earlville
Sherburne
North Norwich
Norwich
Oxford
Greene
Brisben
Chenango Forks
Port Crane
Binghamton

Chenango Canal
1837-1877

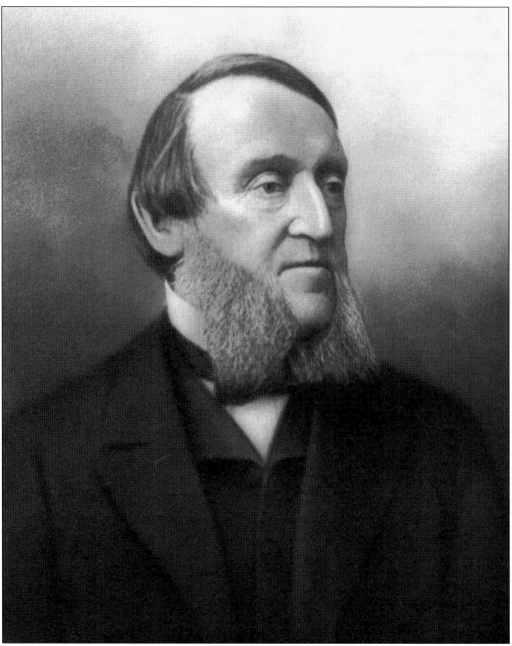

William Jarvis McAlpine, the principle assistant engineer on the canal, used the Jervis invention of rain gauge and a sluice to measure the water supply at the summit level. The rain gauge measured the amount of rainfall. A sluice 24 feet long and 10 feet wide was inserted into a reservoir to discharge water. A weighted wooden ball was dropped at the top and timed to the bottom. Because the volume of the sluice and rate of flow was known, accurate measurements of the amount of water leaving a reservoir could be made. Together, the two devices accurately measured the amount of water runoff from rainfall. (Courtesy of the American Engineering Society.)

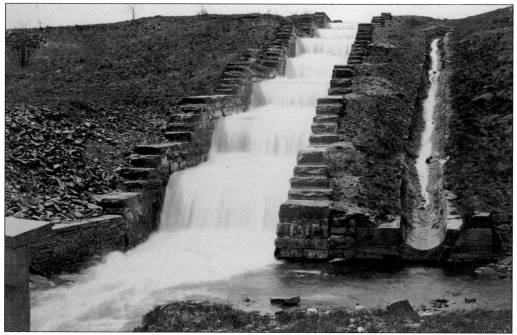

Using the existing technology of the day, Jervis incorporated many steps in his Eaton Brook Reservoir spillway to break up the energy of the falling water to protect the earthen dam. Jervis would later invent the reverse curve spillway, a more efficient way for managing falling water at dams, when he constructed the Croton Aqueduct in the 1840s. (Courtesy of the Eaton Museum Collection.)

The Lake Moraine Spillway is seen here as it appeared around 1914. A long descending spillway was used at Lake Moraine to break the water's energy so it would not wash out the foundation of its earthen dam. (Courtesy of the Hamilton Historical Commission.)

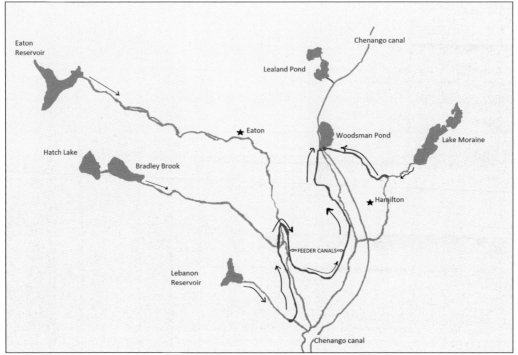

Seven reservoirs and their feeders were built to supply water for the canal at the summit. These included Hatch Lake, Leland Pond, Woodman's Pond, Eaton Brook Reservoir, Lebanon Reservoir, Lake Moraine, and Lebanon Reservoir.

Hatch Lake once was the headwaters of the Otselic River, but its outlet was closed, and its water was redirected through the nearby Bradley Brook Reservoir. Water from Bradley Brook then flowed through a feeder to the canal. (Courtesy of the Eaton Museum Collection.)

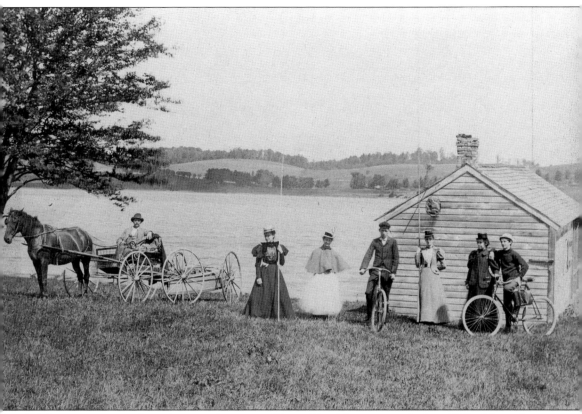

A fishing party poses for a photograph at one of Eaton Brook's camps in the late 1880s. Not only did the reservoirs supply water to the canal, but they also provided recreation destinations for local citizens. Anglers could fish for several species of fish, including largemouth bass, northern pike, cisco, pumpkinseed, bluegill, yellow perch, and white sucker. (Courtesy of the Eaton Museum Collection.)

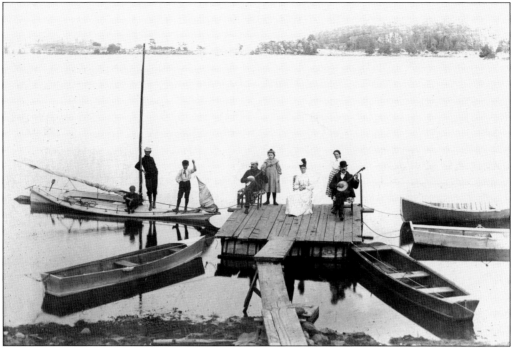

Boaters pause for a banjo music session at a dock near a hotel on Hatch Lake. Hotels sprung up along the lake as people flocked to the country to escape the summer heat. (Courtesy of the Eaton Museum Collection.)

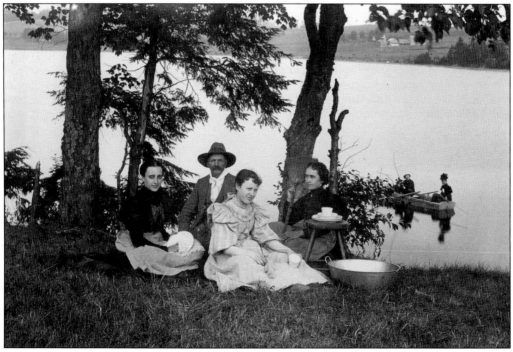

Here, a family enjoys an outdoor meal next to one of Eaton's reservoirs. In the background, a woman and a man fish off a boat. (Courtesy of the Eaton Museum Collection.)

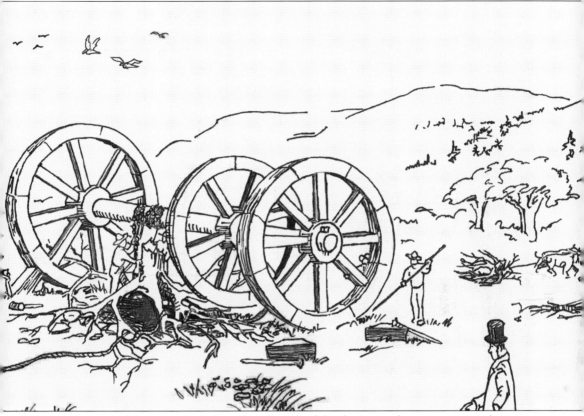

Contractors on the Chenango Canal employed many of the devices and construction techniques used on the Erie Canal. The stump puller was an example of one. The machine had two outer wheels 16 feet in diameter, connected by an axle 30 feet long and with a diameter of 20 inches. In the middle of the axle was a fixed third wheel 14 feet in diameter. To pull the stump, the axle was moved over the stump. The center wheel was rotated by a rope pulled by oxen. The wheel in turn rotated the axle with a chain wound around it that was attached to the stump. The rotation of the axle exerted an upward force on the chain, which pulled the stump out. (Courtesy of the Erie Canal Museum, Syracuse, New York.)

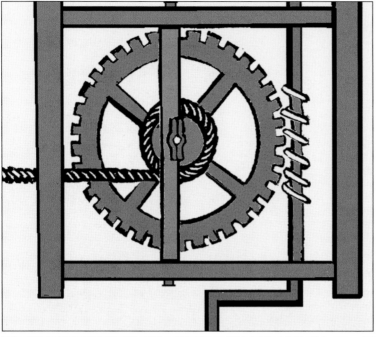

To remove smaller trees, another Erie Canal device called an endless screw machine was used. The boxlike machine was secured to a spot about two tree-lengths away. A cable from the machine was then attached to the top of a tree. A person would then operate a hand crank on the machine, which turned a gear inside that wound the spool of cable on a drum, in turn pulling the tree down by uprooting it.

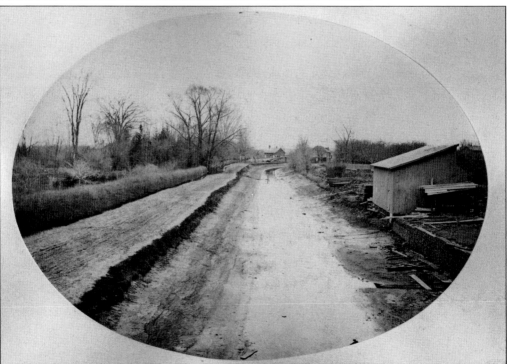

The empty canal prism in Clinton, New York, is pictured in 1877. The canal prism was 4 feet deep, the bottom was 26 feet wide, and the top was 40 feet across, following the dimensions of the Erie Canal. The Erie underwent enlargements, but the Chenango Canal never did, which prevented many Erie boats from using the Chenango in its later years because they were too big to fit on the smaller canal. (Courtesy of the Clinton Historical Society.)

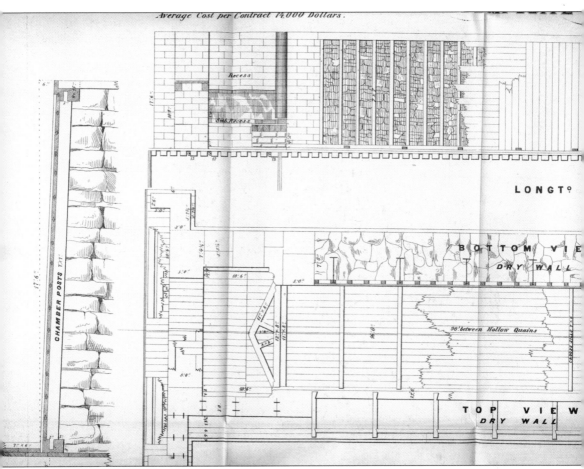

This 1859 New York State diagram shows how a rubble stone foundation backed the wood construction of a lock. The wood lining the lock was made of white pine that would swell when wet, making the lock watertight. This method was probably the fastest and cheapest way of constructing a lock but would later become problematic.

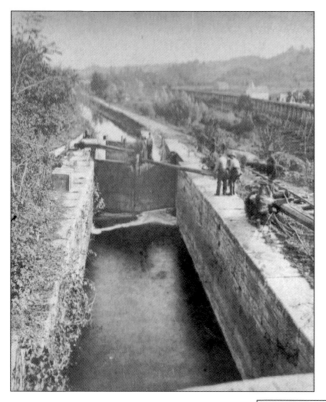

The center section of the three-lock combine is seen in this view looking north. The men at the left are working on a derrick that was probably used to disassemble the lock when the canal closed in 1877. (Courtesy of the Limestone Ridge Historical Society.)

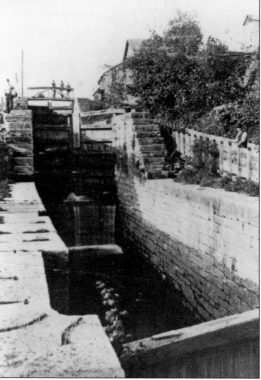

The middle lock of the three-lock combine looking south. The men at the left are standing in a sluice that carried excess water around the lock when the gates were closed. Lock sluices kept a supply of water flowing in the canal during locking operations. (Courtesy of the Limestone Ridge Historical Society.)

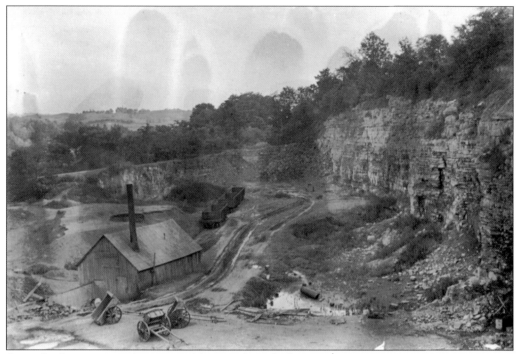

Stone for the many canal structures like aqueducts, locks, and bridges came from local limestone quarries like the Putnam in Oriskany Falls. Limestone was used in all but two locks. (Courtesy of the Limestone Ridge Historical Society.)

Sidney Putnam (pictured) could neither read nor write but could add large columns of numbers in his head, counting up profits from selling his stone for the canal construction. (Courtesy of the Limestone Ridge Historical Society.)

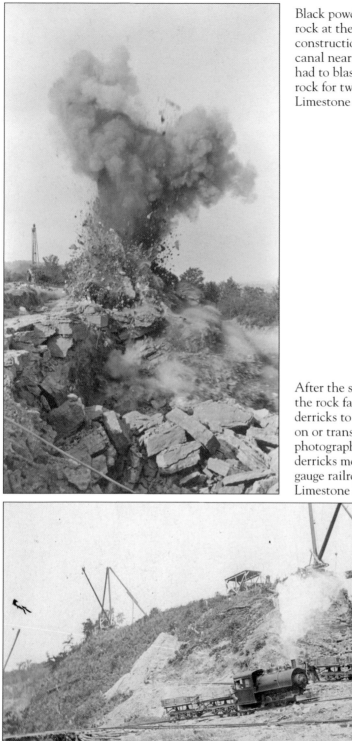

Black powder was used to break up rock at the Putnam Quarry and canal construction site. At the cut in the canal near the summit level, workers had to blast through 25 feet of solid rock for two miles. (Courtesy of the Limestone Ridge Historical Society.)

After the stone was loosened from the rock face, it was moved by derricks to where it could be worked on or transported. In this c. 1900 photograph of the Putnam Quarry, derricks move stone to a small-gauge railroad. (Courtesy of the Limestone Ridge Historical Society.)

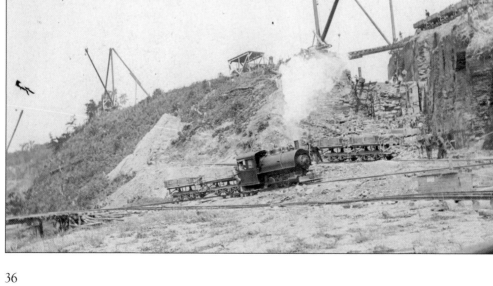

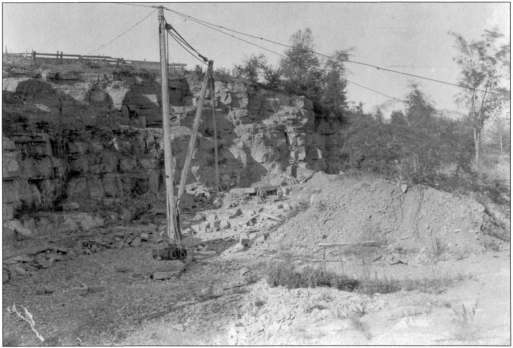

This Putnam Quarry Derrick was supported at the top by long cables. These wooden derricks were able to raise and move large blocks of stone weighing tons. (Courtesy of the Limestone Ridge Historical Society.)

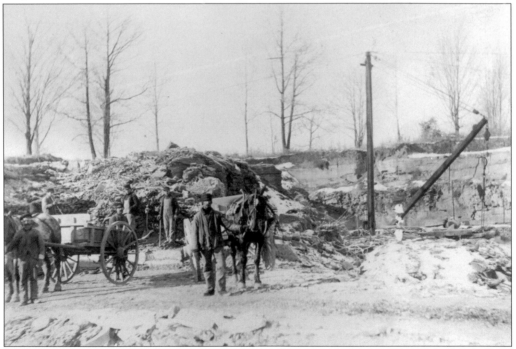

Stone for the canal also came from the North Norwich Quarry. A derrick in the center of the photograph loaded stone into carts. (Courtesy of the Chenango County Historical Society.)

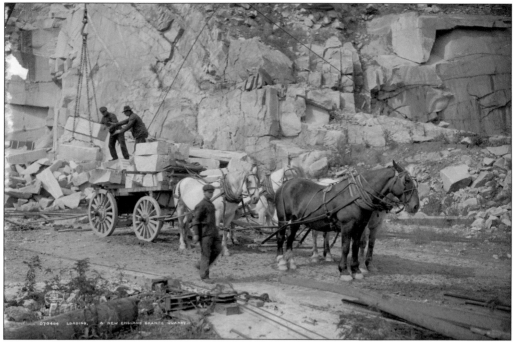

Derricks loaded canal stone onto wagons like this one for transport. The heavy wagons would transport the stone to the worksite, where similar derricks would swing the stones into place. (Courtesy of the Library of Congress.)

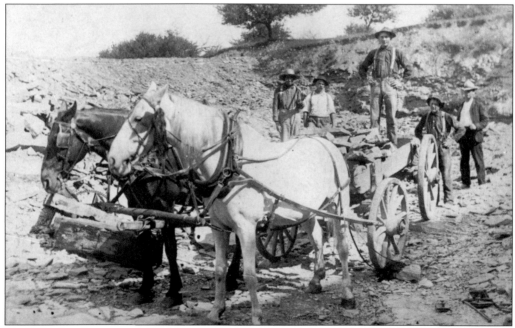

Large blocks of stone were used in the ends of the lock where water would be the most stressful on the structure. Smaller stones were used in the bulk of the structure. These were usually lifted by hand onto wagons, like this one in the Clinton Quarry around 1870. (Courtesy of the Clinton Historical Society.)

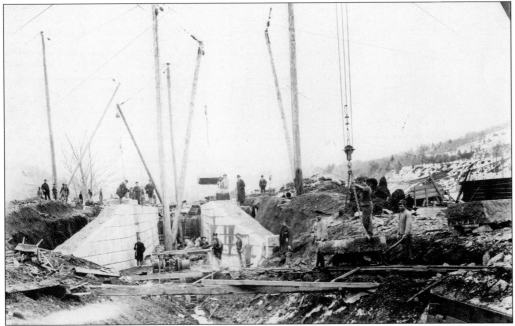

Started in 1836, the year the Chenango Canal was finished, the Black River Canal also employed derricks. In this photograph, workers move stone into position at lock 28 of the Black River Canal. Suffering setbacks, this canal would not be completed until 1855 and operated until 1924. (Courtesy of the Rome Historical Society.)

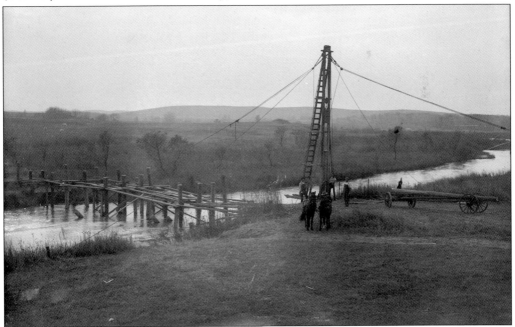

To build aqueducts and bridges in wet, muddy conditions piles were used for the base of construction. Long wooden poles were driven into the ground with a pile driver until they found rock or hard ground. The structure was then attached to these. (Courtesy of the Nebraska State Historical Society.)

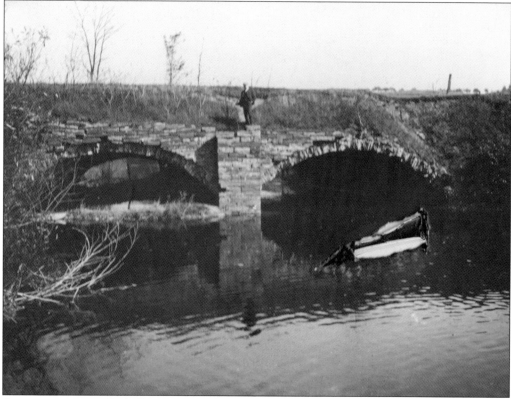

A man inspects the Earlville stone aqueduct in the 1920s. When stone arches for aqueducts were constructed, wooden structures called centering were built to support the stones until they were set in cement and held in place by keystones. (Courtesy of Quincy Square Museum.)

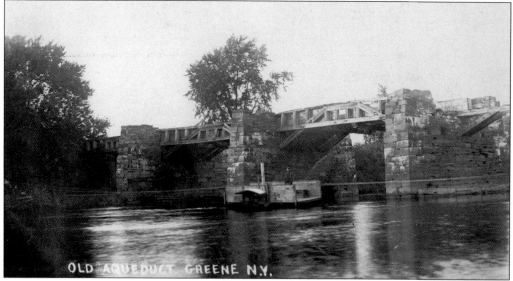

OLD AQUEDUCT GREENE N.Y.

Not all aqueducts were completely made of stone. The largest Chenango Canal aqueduct was a wooden trough supported by stone towers 25 feet above the Chenango River in the town of Greene. (Courtesy of the Greene Historical Society.)

A winter photograph shows the Greene Aqueduct over the Chenango River. Leaking water created huge icicles in the winter months. (Courtesy of Paul and Mary King.)

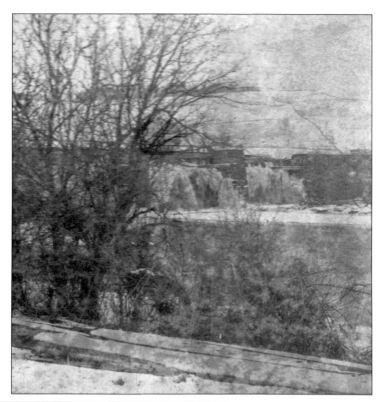

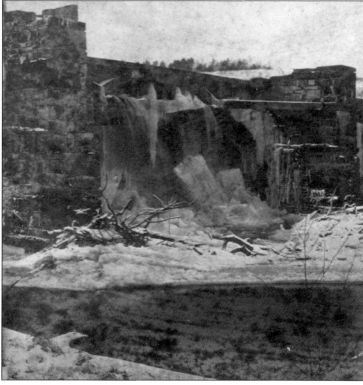

This close-up of the Greene Aqueduct in winter shows the massive icicles made from the leaks in the structure. Repairs to aqueducts usually occurred during the winter months when the canal was not in use. When the canal was abandoned, the wooden structures quickly deteriorated. (Courtesy of Paul and Mary King.)

Oxford Memorial Library, Oxford, N. Y.

The building of the canal necessitated the building of many bridges. William Burr, a cousin of former vice president Aaron Burr, had invented a wooden truss bridge in 1804. The Burr truss bridge design became the most adopted bridge structure along the canal. Burr resided in this home near the canal in Oxford, New York. (Courtesy of the Oxford Historical Society.)

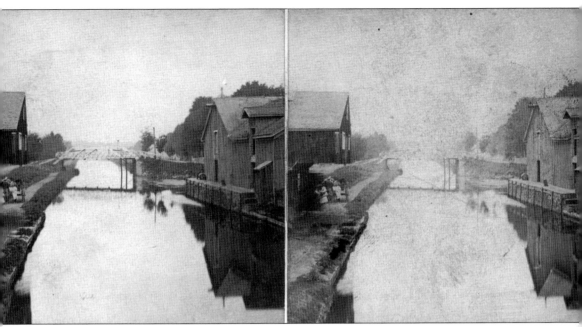

The Burr truss bridge combines an arch and a truss to carry loads while keeping the bridge rigid. This was an improvement over a bridge employing just one of the two. Although an excellent design for the time, the all-wood construction became problematic, as these bridges were subjected to rot from the elements over time. There are several newspaper accounts of these bridges collapsing over the canal while in use. A classic example of a wooden Burr truss bridge spanned the canal on Lebanon Street in Hamilton, New York. (Courtesy of the Hamilton Historical Commission.)

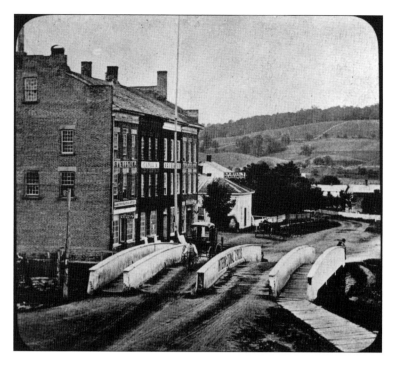

This is a view of the wooden Lebanon Street Bridge in Hamilton. This bridge had two paths for wagon traffic and two sidewalks for pedestrians. (Courtesy of the Hamilton Historical Commission.)

The wooden Lebanon Street Bridge was built over the canal near the exchange building in Hamilton, New York. It was replaced by an iron bridge of a new design in 1862. (Courtesy of the Hamilton Historical Commission.)

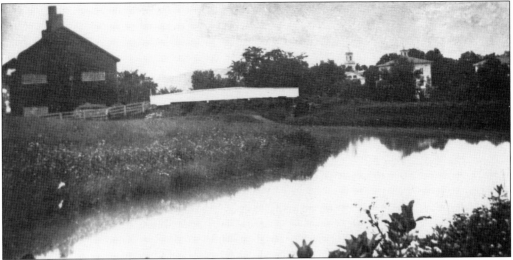

A wooden bridge spans the canal in Oxford, New York. By the early 1840s, many of the wooden canal bridges began to deteriorate to the point of collapse. A replacement for the Burr design was sought by the state. (Courtesy of the Oxford Historical Society.)

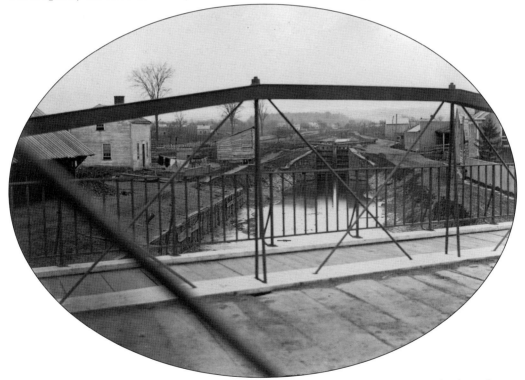

Squire Whipple patented his bowstring arch truss bridge design in 1841. It was the first all-iron bridge trussing system to find wide use. The Whipple bridge was such an improvement over the Burr design that it replaced the Burr bridge as the standard for the Erie and Chenango Canals. This photograph of the College Street Bridge in Clinton, New York, is a close-up of the iron construction of the Whipple bridge. Lock 19 is in the background. (Courtesy of the Hamilton College Library Special Collections.)

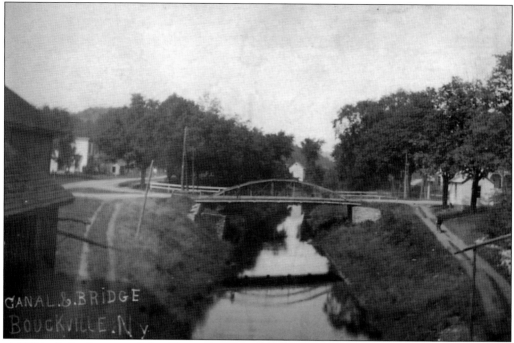

A Whipple bridge carried the Cherry Valley Turnpike over the canal in Bouckville, New York. In this view of the Bouckville Bridge, one can see how space was allotted for the towpath on the right side of the bridge. (Courtesy of Mishell Kyle Forward-Magnusson.)

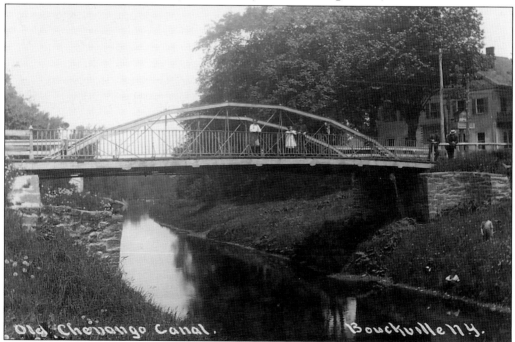

This is a northward view of the Bouckville Whipple bridge. The Bouckville Inn is just visible to the right, showing its proximity to the canal. (Courtesy of the Town of Madison Historical Society.)

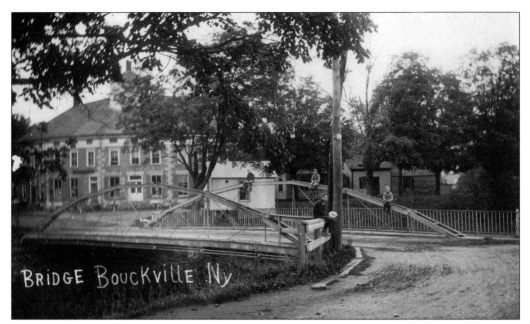

BRIDGE BOUCKVILLE NY

Boys pose for a c. 1920 photograph while sitting on the Whipple bridge in Bouckville. The famous Coe & Brockett building is in the background. (Courtesy of the Town of Madison Historical Society.)

The fragile condition of some of the canal bridges led the state to pass laws to protect them. This 1870 broadside warns users that a $15 fine would be levied if they rode or drove animals over a canal bridge faster than a walk. There were 162 bridges over the canal.

$15 FINE!

For Crossing State Bridges Faster than on a Walk.

The attention of all persons crossing the Bridges over any Canal, Feeder, Stream or River belonging to the State, is called to the following law of this State, passed April 19, 1862. Chap. 354, Laws of 1862, reads as follows:

Sec. 1. It shall not be lawful for any person to *lead*, *ride or drive any horse or horses, mule or mules, faster than on a walk, over any Bridge* belonging to or under the control of the State, which is or may be hereafter erected over any canal, feeder, stream or river thereof.

Sec. 2. No person shall hereafter drive *any Cattle* across any bridge or bridges referred to in the first section of this act at a faster rate than upon a walk, and shall not in so driving them over permit more than *twenty-five* to be upon such bridge at any one time.

Sec. 3. Any person violating either of the provisions of this act, shall be liable to a penalty, for each offense, of $15, to be sued for and recovered in any court having cognizance thereof, by the contractor, in the name of the people of this State, whenever such bridge or bridges shall be embraced in his repair contract, and in all other cases by the Superintendent of Canal Repairs.

Repair Contractors and Superintendents of Canal Repairs upon the Western Division, are hereby directed and required to see that the provisions of the above law are rigidly enforced.

Canal Commissioner's Office,
ROCHESTER, September 8th, 1870. }

JOHN D. FAY, Canal Com'r.

Union & Advertiser Print.

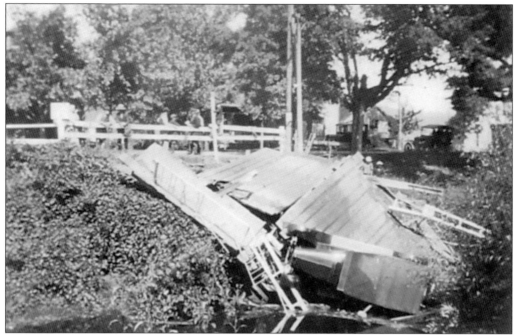

When a truck crossed the Bouckville Canal Bridge in 1925, the bridge collapsed. The collapse came 52 years after the canal had closed, a testimony to the durability of the Whipple design. (Courtesy of Mishell Kyle Forward-Magnusson.)

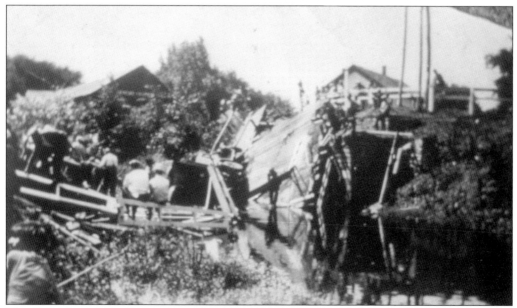

The ill-fated truck can be seen on its side in this photograph of the Bouckville bridge collapse in 1925. Two onlookers take a seat on the wreckage of the bridge truss. (Courtesy of Mishell Kyle Forward-Magnusson.)

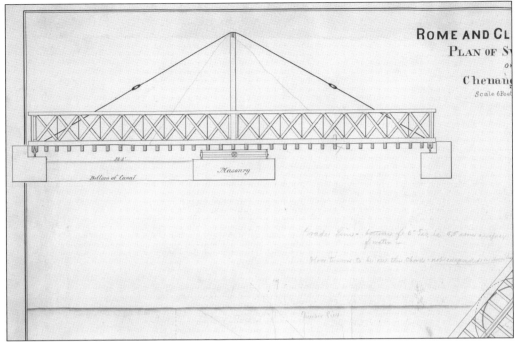

Bottom of Canal

Masonry

The expansion of train routes across the canal created a problem for bridge designers. Trains could not cross on regular canal bridges, as they had to travel a level path. Boats could not travel under a low, stationary train bridge. The solution was the invention of the swing bridge. Swing bridges pivoted on a base to swing into position for train crossing and moved out of the way for boat traffic. Built in 1871, the Clinton swing bridge was 81 feet long and crossed 28 feet of water. (Courtesy of the Clinton Historical Society.)

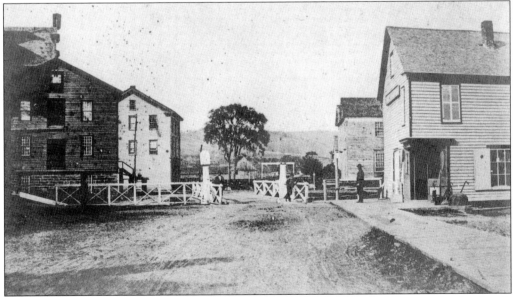

A swing bridge was employed over the canal in Sherburne, New York. The straight, level path over the canal was ideal for heavy loads crossing it. (Courtesy of the Sherburne Historic Park Society and Museum.)

49

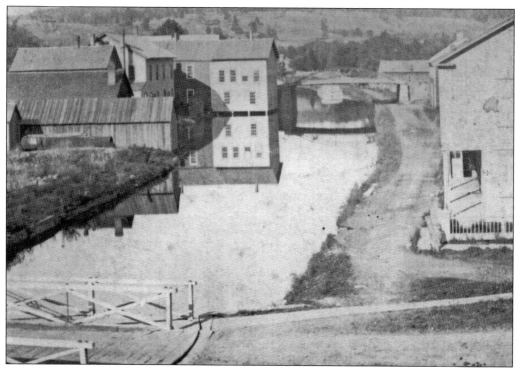

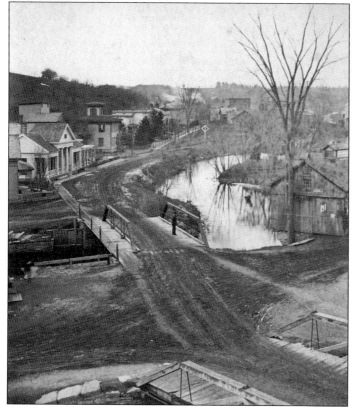

The benefits of the swing bridge can be seen in this photograph of two bridges in Greene, New York. The high arch of the Whipple bridge in the background made it difficult or impossible for some traffic to cross it. This was not the case with the swing bridge in the foreground, which had no elevation. (Courtesy of the Greene Historical Society.)

Local entrepreneurs took advantage of the sides of simple road bridges like these in Oriskany Falls. Advertisements for local businesses were painted on their sides. The canal bridge at the bottom has an advertisement for canal horses painted on it. (Courtesy of the Limestone Ridge Historical Society.)

Three

THE NORTHERN CANAL

The Northern Canal was noted for its steep accent to the summit level. Of the 116 locks, 76 were built between Utica and the summit level at Bouckville, a distance of only 23 miles. It was not uncommon to have towns in this section with multiple locks; Oriskany Falls had seven, as well as the only combination lock on the canal. The steep grade necessitated the building of the seven reservoirs at the summit level to provide enough water to make the canal work.

Towns in the northern section became textile centers when industry changed from waterpower to coal-fueled steam power. At one time, the Utica Steam Cotton Mill, located near the terminus of the canal, was the largest factory in New York State. It prospered because of the cheap availability of coal shipped from Pennsylvania. The Franklin Iron Works, located near Clinton, also relied on the canal coal, as well as a transportation system for its product of pig iron. Whiskey, cider, hops, and produce were some of the many items shipped via the canal from this area.

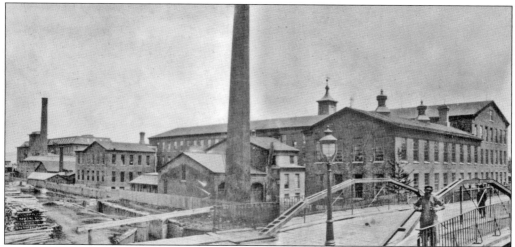

This is a view of the Utica Steam Cotton Mill. A coal boat can be seen tied up to the dock of the large factory. Coal-fired steam plants enabled Utica to become a textile center. (Courtesy of the Oneida County Historical Society.)

The Utica Insane Asylum, built in 1843, was the first publicly funded institution for the mentally ill in America. The Greek Revival building, set on 130 acres, relied on the flow of Chenango Canal water to power a waterwheel that pumped water throughout the institution. (Courtesy of the Oneida County Historical Society.)

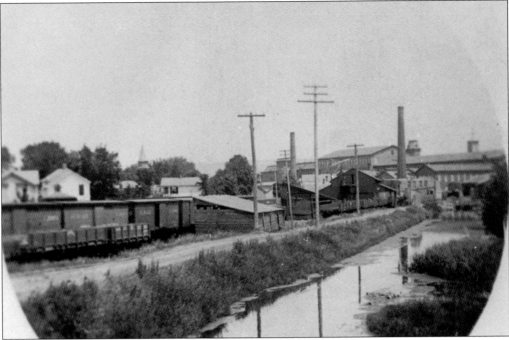

The canal approaches the Utica Cotton Steam Mill, seen in the background. The railroad that would eventually replace it is to the left of the canal. (Courtesy of the Oneida County Historical Society.)

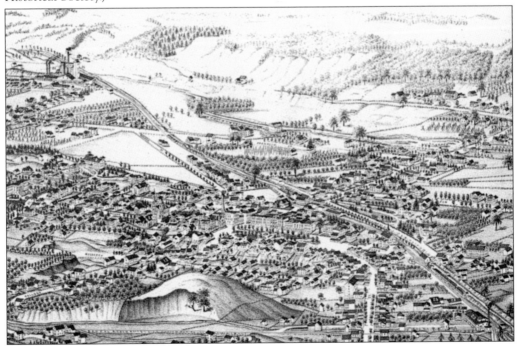

This bird's-eye drawing of Clinton, New York, shows how the canal went through the town on its way to the Franklin Furnace, depicted in the upper left-hand corner. The railroad closely followed the path of the canal through the town. (Courtesy of the Clinton Historical Society.)

The Augustus Fake store, situated on the green in Clinton, prospered by being close to the canal. Area stores could stock a wider selections of goods, including fresh oysters, with the coming of the canal. (Courtesy of the Clinton Historical Society.)

Large forwarding and storage structures, like this one in Clinton, were built along the canal. Area products were stored there until they could be shipped to market. Incoming goods were held there until their buyers could pick them up. (Courtesy of the Clinton Historical Society.)

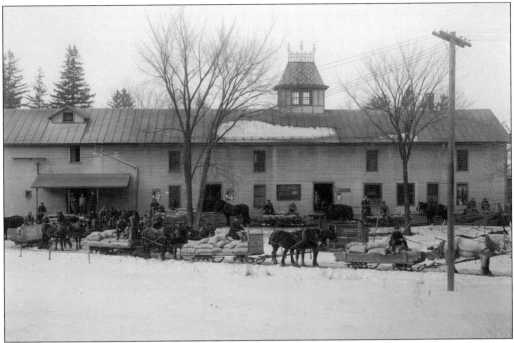

This is the back side of the same large storage and forwarding facility in Clinton. This building took on a similar function for the railroad when it came to Clinton in the 1860s. (Courtesy of the Clinton Historical Society.)

Canal forward and storage warehouses lined the canal near the College Street Bridge in Clinton, New York. Today, this building is occupied by a dry cleaning business and apartments. (Courtesy of the Clinton Historical Society.)

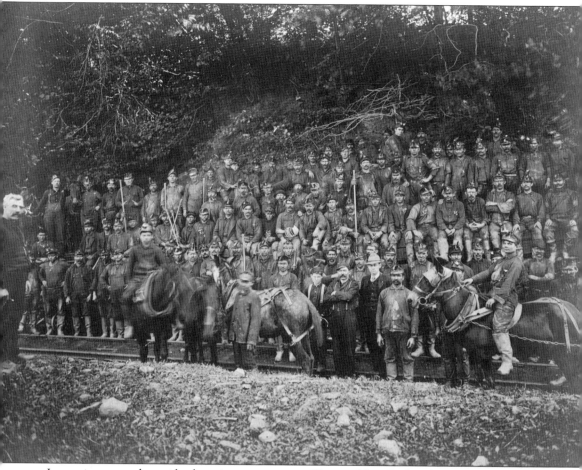

Iron miners stand outside the mine entrance in Clinton, New York. The iron industry of the town of Kirkland relied on the canal to transport iron ore that was mined there. When coal became available via the canal, area blast furnaces began the production of pig iron. The area blast furnaces also relied on the canal for transport of their iron to markets up and down the canal. (Courtesy of the Clinton Historical Society.)

Like workers on the canal construction, Clinton miners were largely a group of immigrants who worked tirelessly under harsh conditions. (Courtesy of the Clinton Historical Society.)

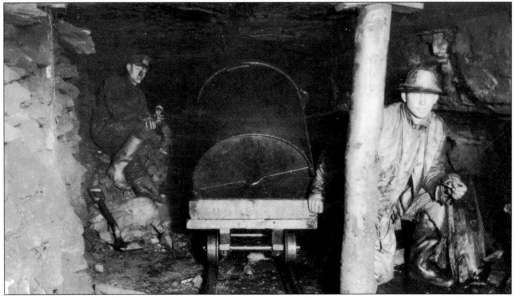

Clinton iron miners had to work in cramped quarters underground. Using shovels, pickaxes, and pails, miners dug the iron ore out of the ground. (Courtesy of the Clinton Historical Society.)

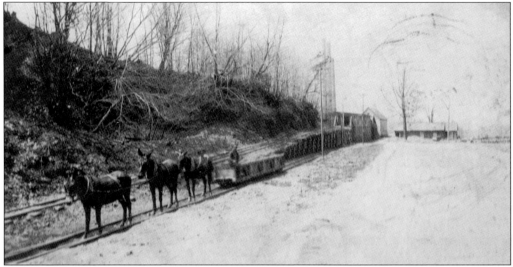

Mules were reliable for heavy work. These mules pull ore carts out of the Clinton iron mine. Mule teams were also employed to pull the heavy canalboats. Two mules usually pulled boats, which often weighed more than 50 tons. (Courtesy of the Clinton Historical Society.)

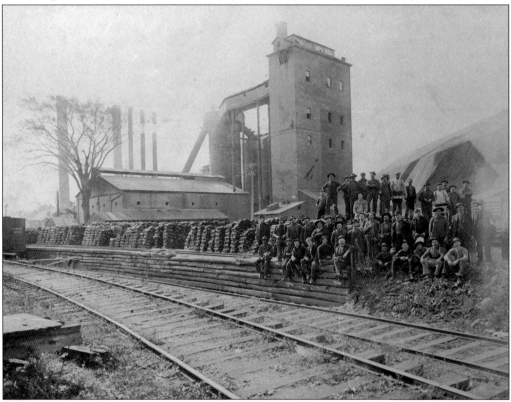

The Franklin Furnace, built in 1852 on the canal just outside Clinton, received tons of iron ore from the Clinton mines. The canal provided coal for the furnace and a way to ship the iron to market. Pig iron lies stacked like cordwood on the loading dock of the Franklin Furnace. The canal ran on the other side of the building. (Courtesy of the Clinton Historical Society.)

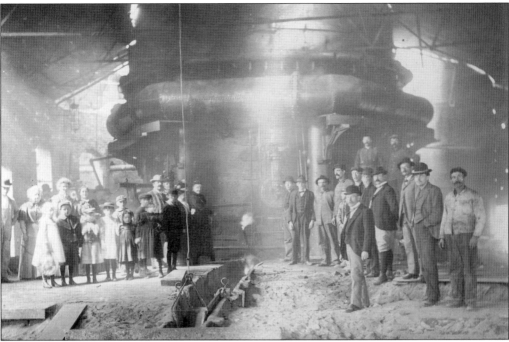

The large blast furnace in the background used tons of coal to separate the iron from the slag. Melted iron poured out of the furnace into molds and then cooled into transportable pig iron. (Courtesy of the Clinton Historical Society.)

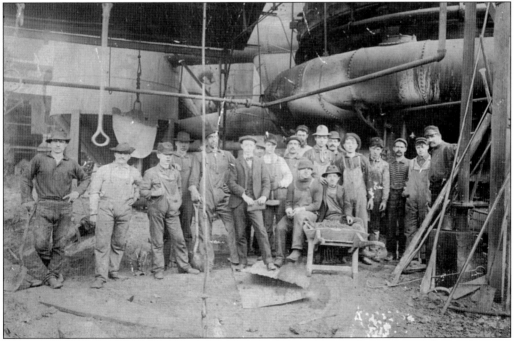

The Franklin Furnace began producing 150 tons of iron a week when it opened in 1852. Tons of cooling slag from the furnace was said to be seen for miles at night. (Courtesy of the Clinton Historical Society.)

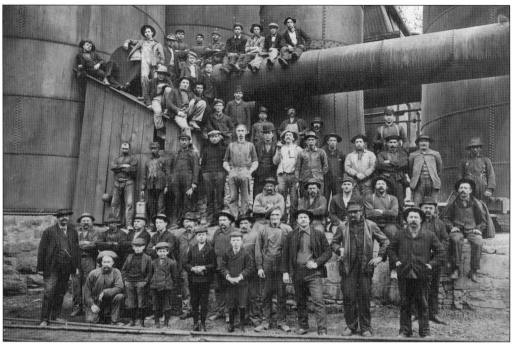

The Franklin Furnace expanded its operation in 1870. Iron production rose to 300 tons per week. The furnace would operate for another 37 years, closing in 1907. (Courtesy of the Clinton Historical Society.)

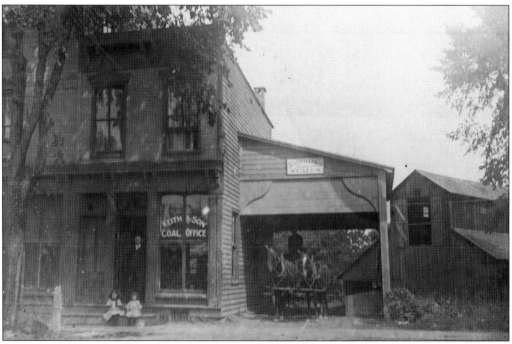

The coal transported cheaply by canalboat allowed for the growth of the coal trading business along the canal. One example was Keith and Son Coal in Clinton, New York. The large coal shed can be seen in the background. (Courtesy of the Clinton Historical Society.)

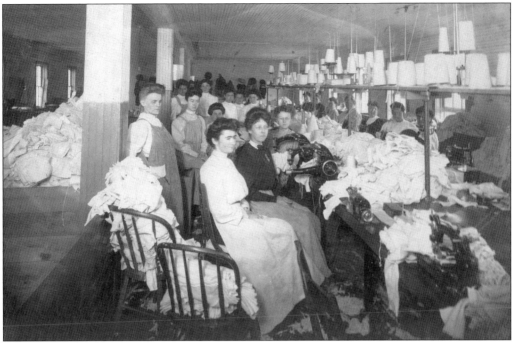

The Clinton Knitting Mill in Clinton, New York, was typical of the expanding textile business in the Utica area made possible by the availability of coal to run steam plants. (Courtesy of the Clinton Historical Society.)

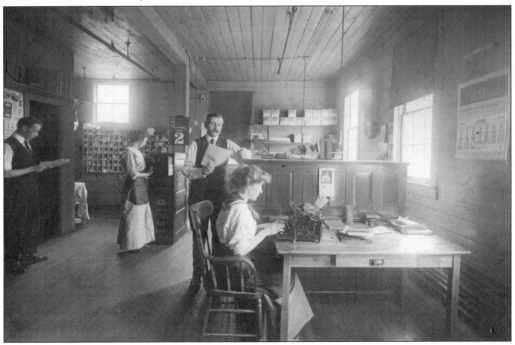

The Central New York area's textile industry, made possible by the canal, employed hundreds of workers for many years. This c. 1914 photograph shows office workers at the Clinton Knitting Mill. (Courtesy of the Clinton Historical Society.)

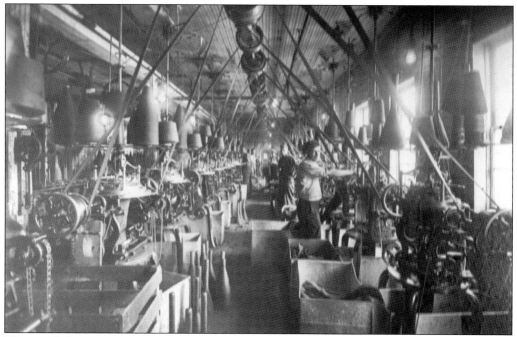

The switch from waterpower to steam power allowed the textile industry to employ many steam-powered machines, like the ones shown in this photograph of the Clinton Knitting Mill. (Courtesy of the Clinton Historical Society.)

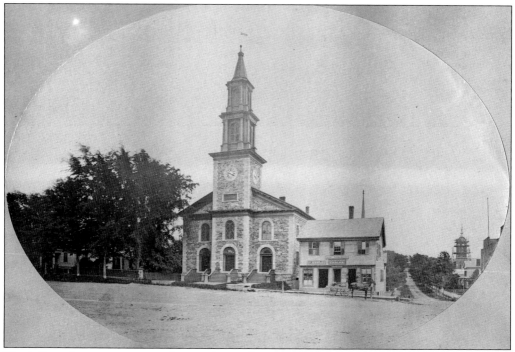

The influx of stonemasons into the area during the canal construction led to the building of several area stone buildings. The Stone Church on the green in Clinton was one of these. (Courtesy of the Clinton Historical Society.)

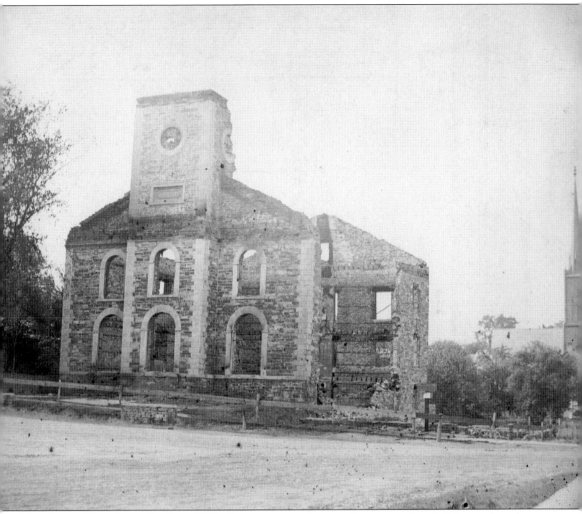

The Stone Church was built in 1836, the same year the canal was completed. It burned to the ground on July 8, 1870. (Courtesy of the Clinton Historical Society.)

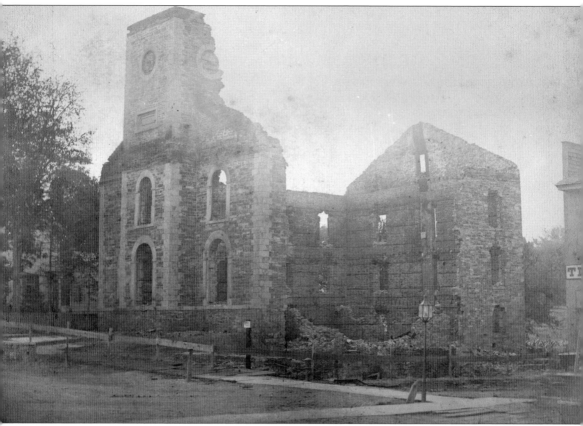

The Stone Church fire started from blowing embers from a house fire across the street. An attempt to the put the fire out was made by the Utica Fire Department, which pumped water from the nearby canal onto the blaze. (Courtesy of the Clinton Historical Society.)

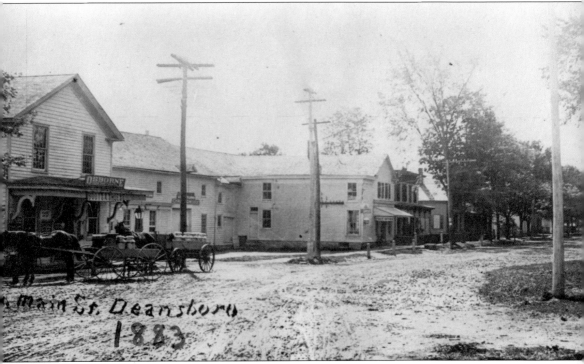

During the life of the canal, Deansboro was known as Deansville. The name was changed when too much Deansville mail ended up in Dansville. During the canal's construction, a labor strike known as Paddy's rebellion occurred in a workers' camp near Deansboro. The local militia was called out to quell the disturbance. The ringleaders were quickly rounded up and locked up in the Deansboro School. (Courtesy of the Town of Marshall Historical Society.)

This northward view up Main Street in Deansboro was taken in 1918. The second structure on the right, built in 1847, was the Deansville Hotel owned by William Hamilton. The canal ran so close to the back of the hotel that a hoist in the attic that was used to lift freight off canalboats. Deansboro prospered from the canal trade; two stores and two warehouses were built on the banks of the canal. Two mills in town used water from the canal to grind grain. (Courtesy of the Town of Marshall Historical Society.)

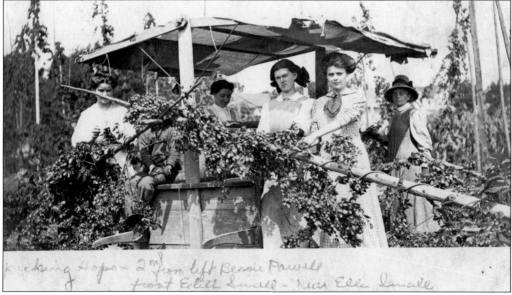

Hop pickers from Deansboro bring in the harvest. Hops were baled and then shipped to market on the canal. (Courtesy of the Town of Marshall Historical Society.)

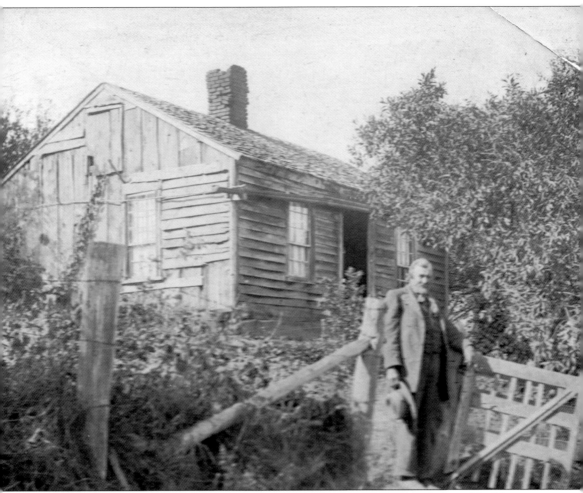

Romance Wyatt, the last Brother Town Indian from Deansboro, worked on the canal for 30 years as a boatman. During the Civil War, Wyatt was a member of 83rd New York Infantry. He fought in the Battles of Chancellorsville and Gettysburg. After the war, Wyatt returned to Deansboro and lived in this house. Upon is his death, he was buried in the Deansboro Cemetery overlooking lock 37 and lock 38. (Courtesy of the Town of Marshall Historical Society.)

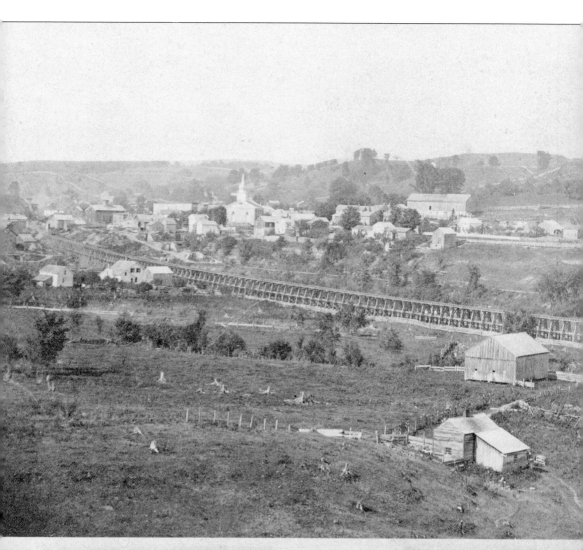

TRESTLE BRIDGE AT ORISKANY FA

BUILT BY IRA WILLIA

GEORGE B. PHELPS & CO., Contractors, Watertown, N. Y.;

In 1869, the Utica, Clinton & Binghamton Railroad looked to extend its line to Hamilton, New York. The major obstacle to the construction was a 30-foot incline at Oriskany Falls. Canal engineers overcame the steep elevation by building three locks in combination to raise boats the 30 feet; these were the only combination locks on the canal. The railroad's answer was to build a long wooden trestle. The Ira Williams and Company was hired for the construction. Locals called it the "mile-long trestle," but it was actually only 1,950 feet long. When completed,

5, N. Y., ON U. C. & B. RAIL ROAD,

VATERTOWN, N. Y., FOR

VEY PARKS, Chief Engineer, J. E. MORSE, Assistant Engineer.

the height of the trestle varied from 10 feet to 33 feet above the ground and there were two curves in it. The construction firm employed an unusual building method. The bents needed to support the trestle superstructure were prefabricated off-site. The line of the canal was near the line of the trestle, so nine canalboats were able to transport the bents to the sites where they were needed. In the photograph, the canal can be seen just beyond the trestle. The three-lock combine is to the right just below the stone Congregational church. (Courtesy of the Limestone Ridge Historical Society.)

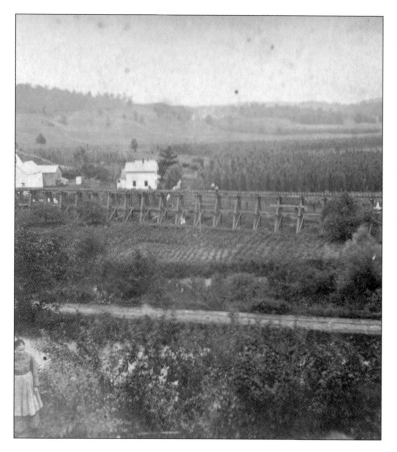

This photograph shows the southern approach to Oriskany Falls. Behind this woman, brush obscures the view of the canal. Past the trestle are large fields of hops, an important cash crop that is grown on tall poles or trellises. (Courtesy of the Limestone Ridge Historical Society.)

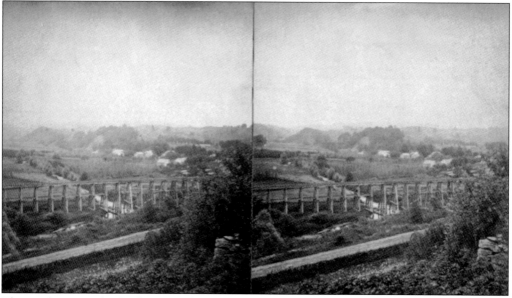

The trestle crosses the Oriskany Creek just north of Oriskany Falls. The towpath parallels the creek but does not cross it in Oriskany Falls. (Courtesy of the Limestone Ridge Historical Society.)

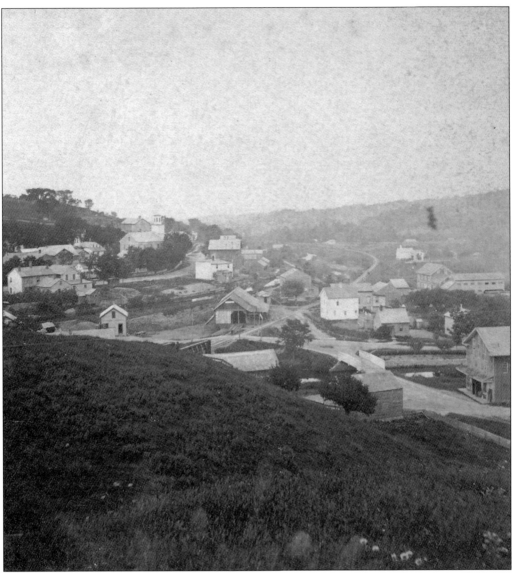

At the left of this photograph, the stone Congregational church sits next to the main road. To the right, the canal can be seen as it leaves the three-lock combine. The train trestle is seen curving out to the distance at the right. The main road, canal, and railroad travel through the narrow corridor into Oriskany Falls. (Courtesy of the Limestone Ridge Historical Society.)

The stone Congregational church in Oriskany Falls was a three-story church built of limestone from the nearby quarry. Stonemasons from the canal aided in its construction, which began in 1834 and was finished in 1845. (Courtesy of the Limestone Ridge Historical Society.)

This is a southern view of the four locks that were in the center of Oriskany Falls. In the foreground is a basin that allowed boats to dock and turn around. The people of Oriskany Falls paid the state $1,304 to have the canal pass through the center of town. (Courtesy of the Limestone Ridge Historical Society.)

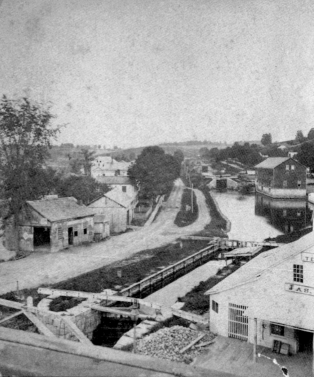

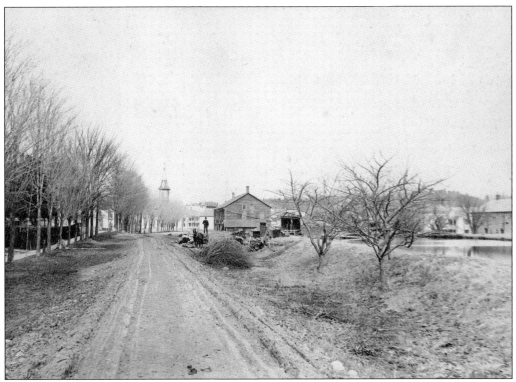

In this northward view of the canal in Oriskany Falls, to the right of the road is the canal berm; the stone Congregational church steeple is in the background; and the James Douglas Canal Warehouse is in the center. (Courtesy of the Limestone Ridge Historical Society.)

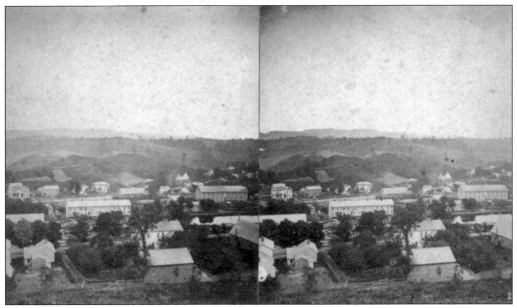

This stereograph shows how the canal bisected the village of Oriskany Falls. The canal can be seen in the right center of the slide. Note the teepee-shaped hop kiln in the upper-right background. (Courtesy of the Limestone Ridge Historical Society.)

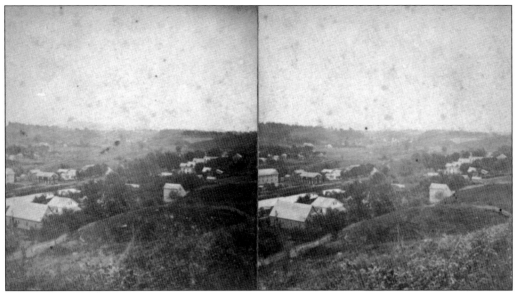

This stereograph shows the canal as it departs Oriskany falls heading south. Many businesses built near the canal in this area in hopes of cashing in on its prosperity. (Courtesy of the Limestone Ridge Historical Society.)

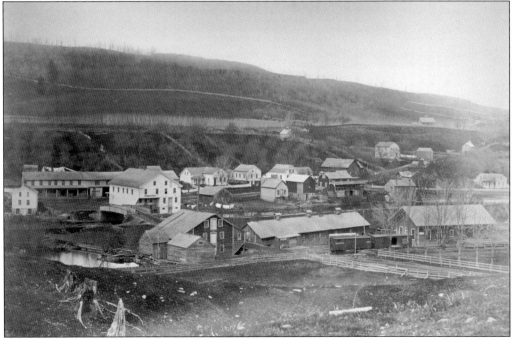

The view is looking down toward the village of Solsville from Madison Hill. Going downhill, the railroad depot appears first, and then the Oriskany Creek dam, followed by the Chenango Canal Bridge over the canal. (Courtesy of the Don Livermore collection.)

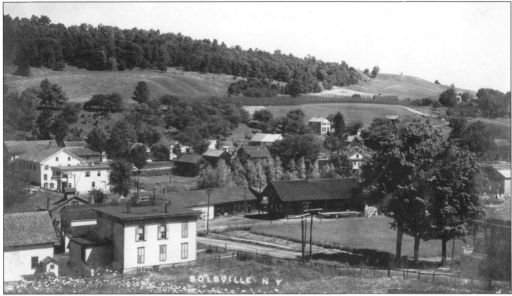

The Chenango Canal, Oriskany Creek, and railroad ran parallel to Main Street in Solsville, New York. Hopyards can be seen on the hill overlooking the town. (Courtesy of the Town of Madison Historical Society.)

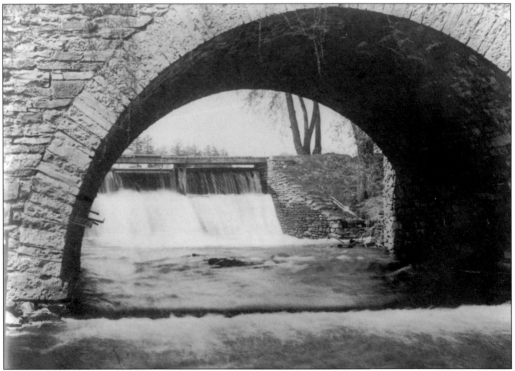

Originally, landowners were afraid that the canal would divert water away from their mills; however, a law was passed that prohibited the Chenango Canal from using any water from the Oriskany Creek. This mill dam was close to the canal bridge in Solsville. (Courtesy of the Town of Madison Historical Society.)

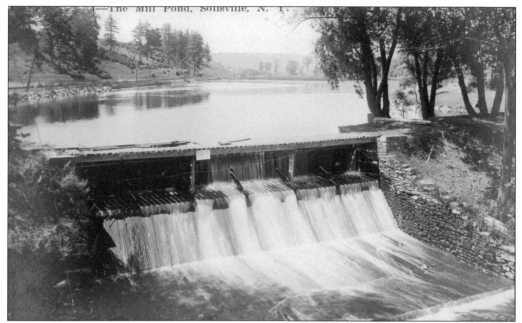

This is a close-up of the Solsville Mill Dam. An advertisement for a baseball game hangs from the center. (Courtesy of the Town of Madison Historical Society.)

ROAD LEADING TO BOUCKVILLE NY.

Photo By A RANGIER

This is a view of the Cherry Valley Turnpike that bisected the canal at Bouckville. The dirt turnpike often became impassable during wet weather. (Courtesy of the Town of Madison Historical Society.)

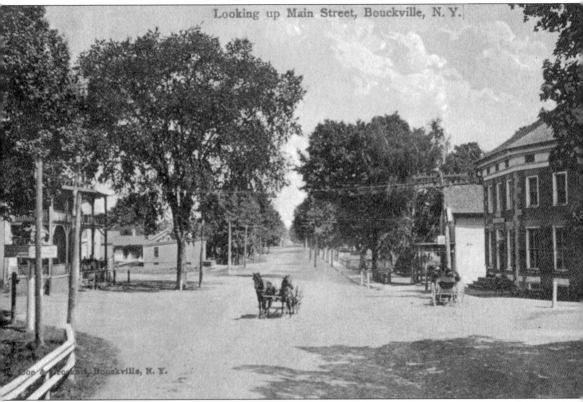

Looking up Main Street, Bouckville, N. Y.

Coe & Brockett, Bouckville, N. Y.

The Cherry Valley Turnpike crossed the Chenango Canal in Bouckville. The area was an ideal place for commerce. This southern view of Main Street was probably taken from the canal bridge. The Bouckville Inn is on the left, and the Coe & Brockett building is on the right. (Courtesy of the Town of Madison Historical Society.)

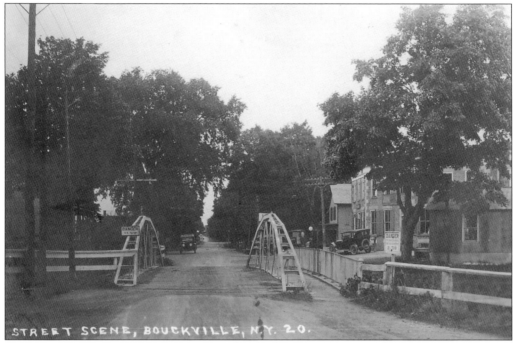

This view of Main Street in Bouckville looks north. The Coe & Brockett building is just past the Whipple bridge on the left. (Courtesy of Mishell Kyle Forward-Magnusson.)

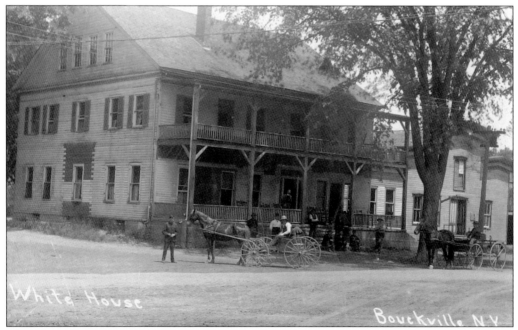

The White House enjoyed the advantage of being on the Cherry Valley Turnpike and near the bank of the canal, just to the left of the building. (Courtesy of Mishell Kyle Forward-Magnusson.)

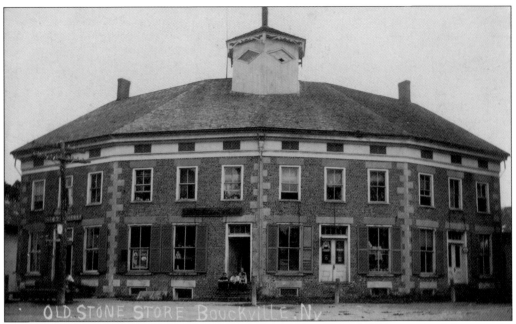

The Old Stone Store, built in 1849 by the Coolidge family, sat on the opposite side of the turnpike from the Bouckville Inn and across from the canal. The building was known as the Coe & Brockett Store. (Courtesy of the Town of Madison Historical Society.)

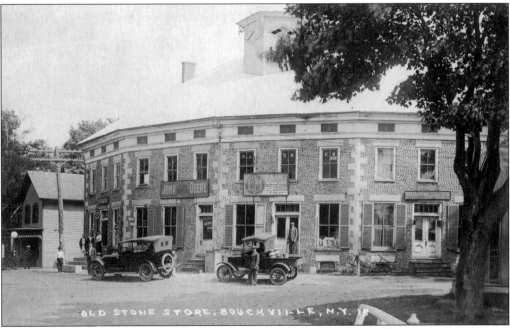

The Coe & Brockett building is seen in this c. 1910 photograph. Designed by James Coolidge, the cobblestone building was probably erected by stonemasons who worked on the canal construction. (Courtesy of the Town of Madison Historical Society.)

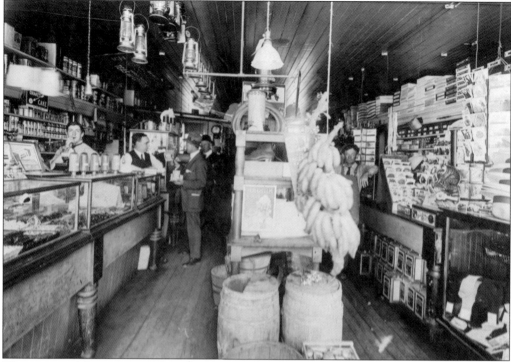

The interior of the Coe & Brockett building is pictured here in the early 1900s. When the building opened in 1851, it held several stores. (Courtesy of the Town of Madison Historical Society.)

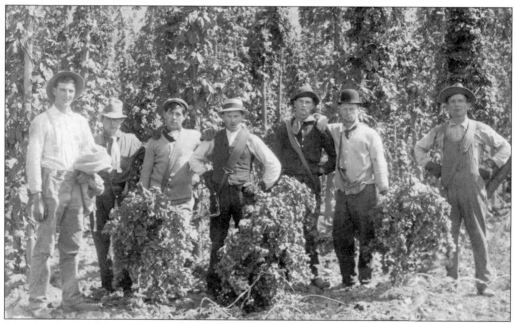

By 1859, almost all hops grown in the United States came from New York. Bouckville, like many communities along the Chenango Canal, shipped hops on the canal. (Courtesy of Mishell Kyle Forward-Magnusson.)

Samuel Mott, born in Saratoga County in 1826, learned the art of making cider from his grandfather. In 1867, Mott traveled via the Erie and Chenango Canals to Bouckville to buy an interest in a vinegar distillery. He soon bought out his partners and, with the aid of his family, made his fortune in the cider business. Many of his buildings were on or near the canal. (Courtesy of the Ruth Mott Foundation Archives.)

Seward Mott, the youngest of the Mott children, left the family business in Bouckville to pursue a military career. He graduated from West Point in 1866 and was tragically killed by an Apache while on duty in Arizona. (Courtesy of the Chenango Canal Association.)

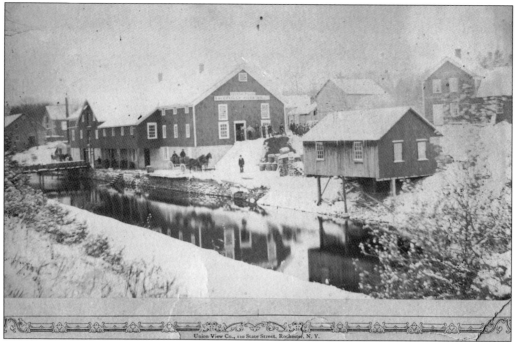

A winter scene of the Bouckville Cider Mill shows its proximity to the canal. Cider barrels could easily be loaded onto the boats from the dock. (Courtesy of the Town of Madison Historical Society.)

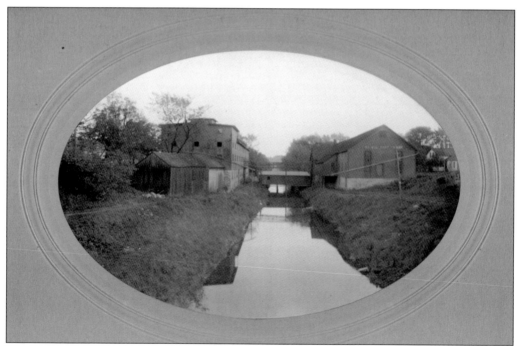

The Bouckville Cider Mill is pictured after the Chenango Canal was closed. In the background, a covered bridge was built over the canal, linking the two buildings. (Courtesy of the Town of Madison Historical Society.)

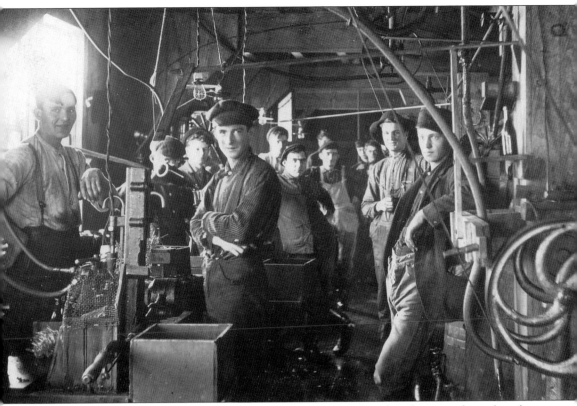

The Bouckville area was known for its many apple orchards. Abundant supplies of apples were processed into cider for shipment to markets via the canal. (Courtesy of Mishell Kyle Forward-Magnusson.)

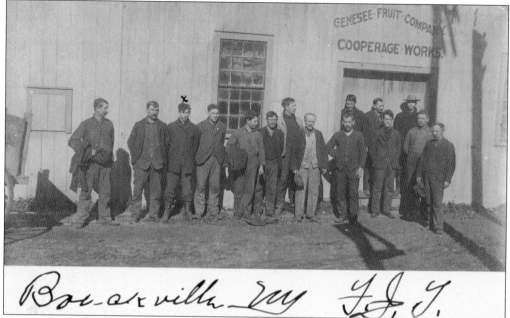

The Genesee Fruit Company became the principal owner of the apple business in Bouckville. Here, workers pose outside the factory in Bouckville. (Courtesy of the Town of Madison Historical Society.)

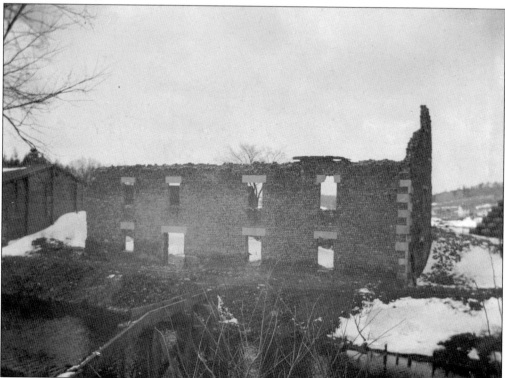

Fire destroyed this cider mill along the canal in Bouckville. The wooden structure crossing the canal carried processed cider from one building to the other. (Courtesy of Helen Nower.)

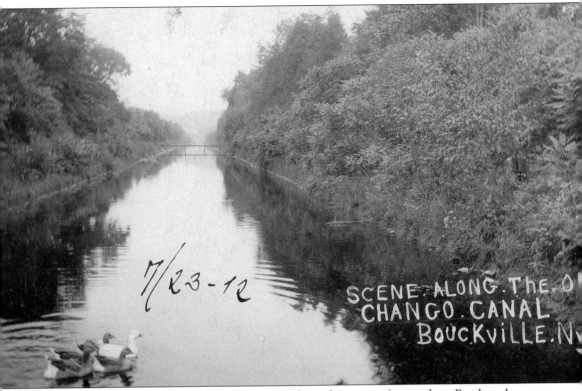

Here is the Chenango Canal as it looked in 1912, thirty-five years after its close. Brush and grass have grown up on the towpath. (Courtesy of the Town of Madison Historical Society.)

CANAL AT BOUCKVILLE, N.Y. 21.

A postcard shows the Chenango Canal winding its way through Bouckville headed north. The Utica terminus on the Erie Canal was 23 miles distant. (Courtesy of the Town of Madison Historical Society.)

Four

THE SOUTHERN TOWNS

The southern towns were greatly affected by the canal. The towns of Pecksport and Port Crane did not exist before the canal and faded soon after its close. Hamilton's green, once a large swamp, owed its existence to the building of the canal. In Norwich, businesses like the Madole Factory and Hayes Piano factory flourished on the canal. The Madole factory used the water of the canal for waterpower and later was supplied coal by canalboat for steam power. The piano factories of Norwich took advantage of the smooth transportation of the canal to move their delicate instruments. The Clarke Brothers Forward and storage buildings were typical of the kind of businesses found in the towns of Oxford, Greene, and Binghamton. Binghamton prospered from the transfer of goods along the canal. With increasing demand for coal, Charles McKinney amassed a fortune in the coal trade.

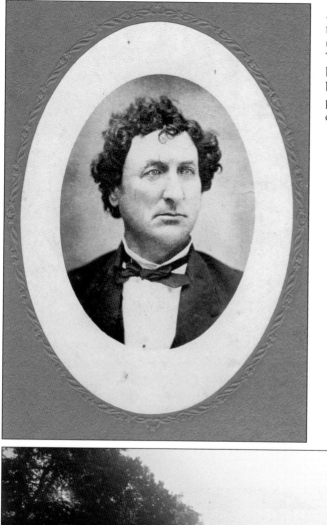

Alonzo Peck created a docking facility for canalboats to load and unload goods on his property. This area near Hamilton became Pecksport, a thriving business area during the canal period. (Courtesy of the Town of Eaton Historical Society.)

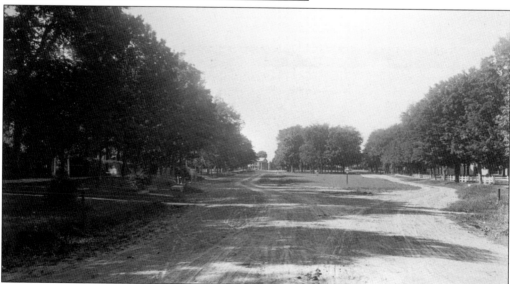

Hamilton might still be a swamp today if not for the foresight of Ferdinand Walker, who suggested that the excavated dirt from the canal be used to fill in the Hamilton swamp. The former swamp became the village green. (Courtesy of the Hamilton Historical Commission.)

To commemorate Walker's work, a grove of maple trees was planted behind the Community Memorial Hospital by the Hamilton Historical Commission. (Courtesy of the Hamilton Historical Commission.)

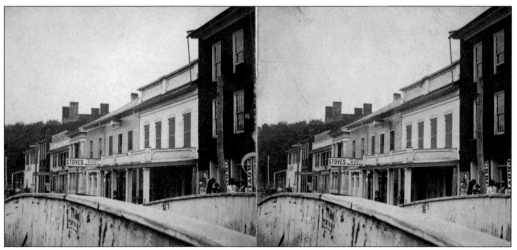

Businesses mushroomed around the banks of the canal and near this canal bridge in Hamilton. During the canal era, several storehouses and a steam-powered gristmill were built on the canal. (Courtesy of the Hamilton Historical Commission.)

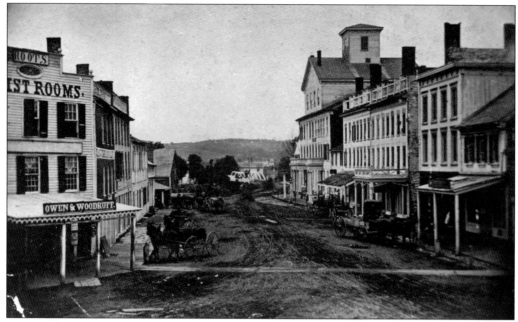

Businesses line the busy Utica Street in Hamilton 1865. The building on the right was the Eagle Hotel, which was said to be the finest hotel between Utica and Binghamton. A canal bridge is visible in the distance. (Courtesy of the Hamilton Historical Commission.)

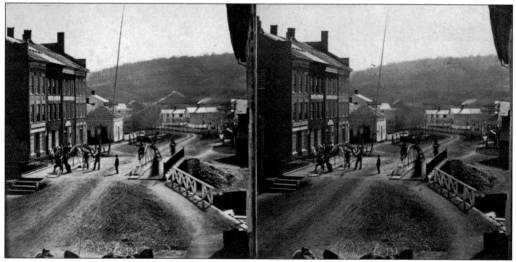

The deteriorating wooden bridge across Lebanon Street in Hamilton was removed when legislators enacted a bill to replace the old one with an iron bridge in April 1862. (Courtesy of the Hamilton Historical Commission.)

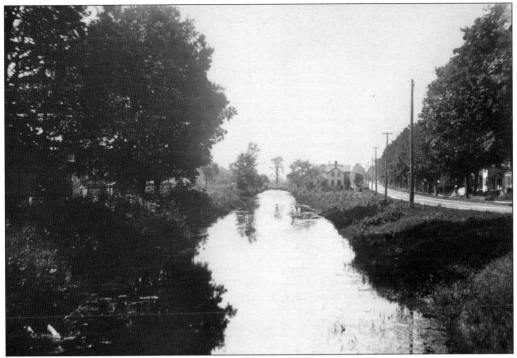

The canal paralleled Utica Street in Hamilton. The waterway took a relatively straight path through the town. (Courtesy of the Hamilton Historical Commission.)

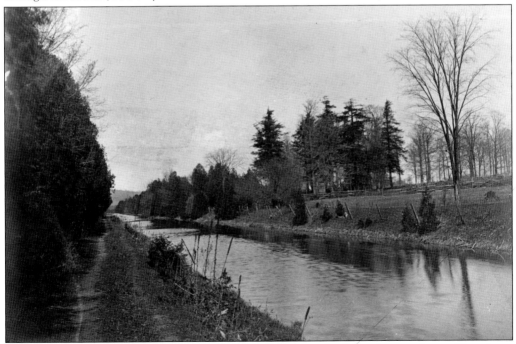

Trees and bushes have started to encroach on the towpath along the canal near Hamilton. Without constant maintenance, plant growth would quickly choke the canal. (Courtesy of the Hamilton Historical Commission.)

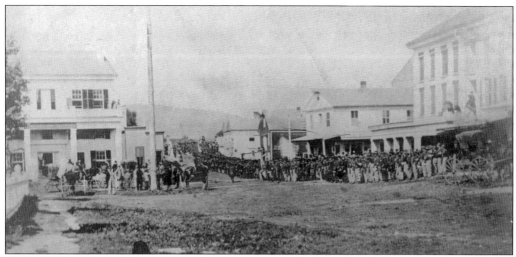

Civil War soldiers line the street in Sherburne and on the canal bridge in the background. Sherburne benefitted from the growth of the textile business, which was made possible by the canal. (Courtesy of the Sherburne Historic Park Society and Museum.)

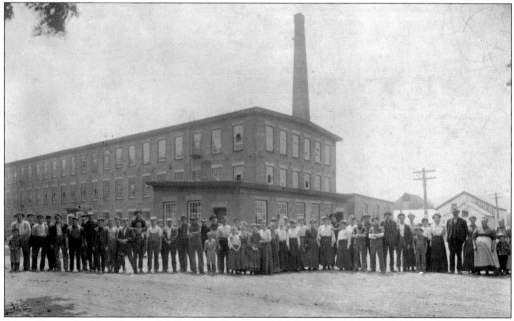

As in Utica, the Ross Cotton Mill in Sherburne was built next to the canal. This allowed for easy access to the supply of cheap coal to fire the steam-power plants of the textile mill and a way to ship product to market. (Courtesy of the Sherburne Historic Park Society and Museum.)

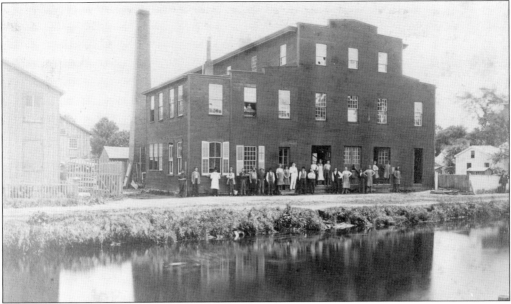

The Hall and Steinburg Sash and Blind Mill, seen here around 1872, was built on the east bank of the canal in Norwich. The site later became the Berglas Plant. (Courtesy of the Chenango County Historian's Office.)

The Carpenter House, built in 1812, was a popular resting place for canal travelers in North Norwich. It burned in 1890. (Courtesy of the Chenango County Historian's Office.)

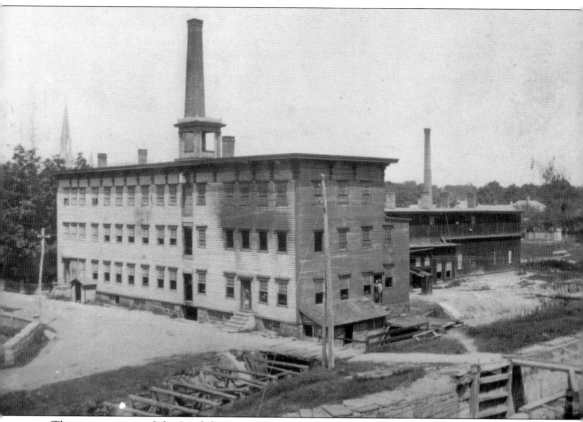

This is an image of the Madole Factory in Norwich, New York. David Madole was famous for inventing an adze eye hammer. His successful hammer factory was situated on the banks of the canal and made use of the nearby lock sluice for waterpower for his machinery. Madole also made ice skates as well as hammers. To promote his skates in the winter he had snow cleared off the ice on the canal so skaters could travel down the frozen waterway. (Courtesy of the Chenango County Historian's Office.)

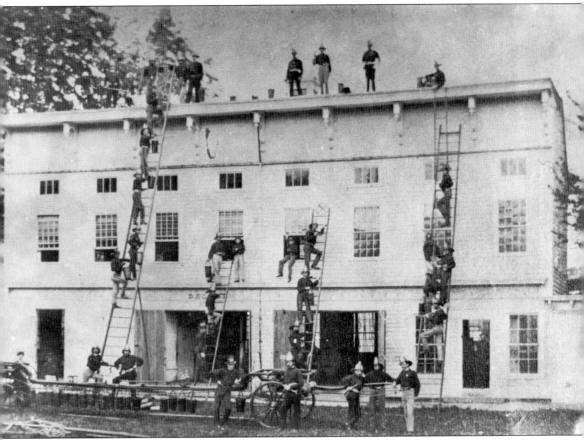

The Hayes Lattin Piano Company located near the canal took advantage of the reasonably gentle transportation of the canalboats for its delicate musical instruments. Part of the Hayes plant, built in 1850, was later made into a firehouse. (Courtesy of the Chenango County Historian's Office.)

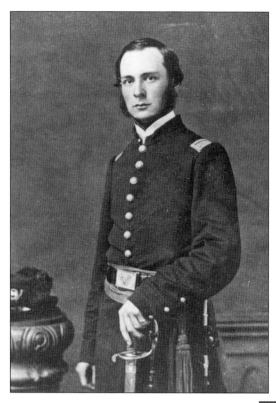

On September 6, 1862, approximately 1,000 men of the New York 114th Regiment left Norwich on 10 canalboats to fight the war. Lt. Charles Underhill of the 114th Regiment, a graduate of Madison College (Colgate University), survived his service to the Union. (Courtesy of the Colgate University Library Special Collections.)

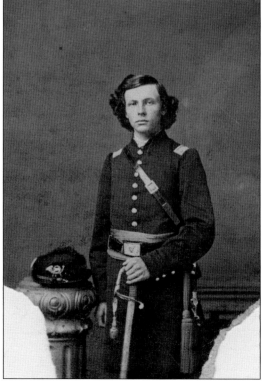

Capt. Charles Tucker of the New York 114th Regiment was also a graduate of Madison College. He was killed in action at the Battle of Port Hudson in 1863. (Courtesy of the Colgate University Library Special Collections.)

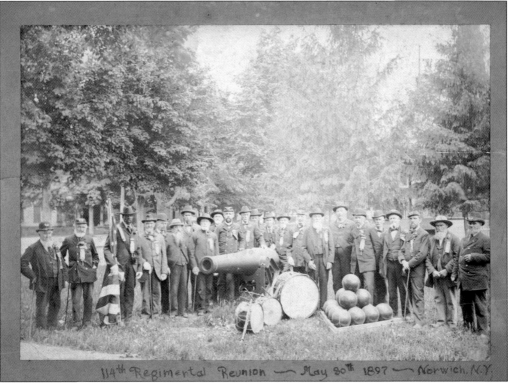

114th Regimental Reunion — May 30th 1897 — Norwich. N.Y.

Survivors of the 114th Regiment had a reunion in Norwich on May 30, 1897, thirty-five years after their departure to the war on canalboats. Of the 1,000 men who left, 317 would not return. (Courtesy of the Library of Congress.)

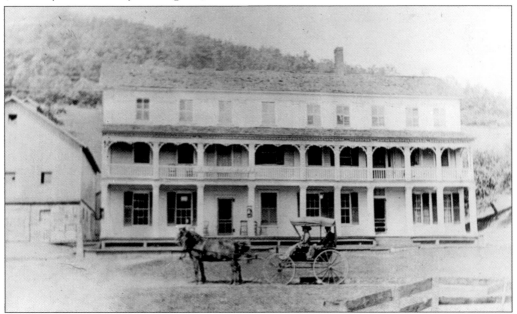

The Half-Way House, located just south of Norwich, was a favorite stopping place for canal travelers. (Courtesy of the Chenango County Historian's Office.)

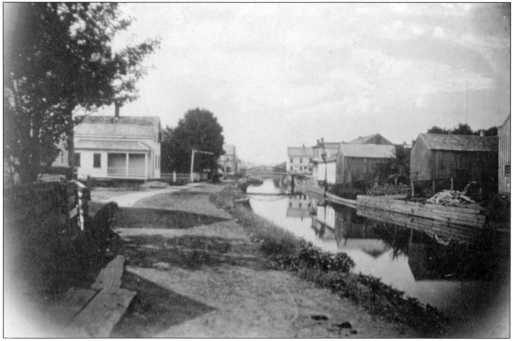

Oxford was the home of Lt. Gov. John Tracy and Theodore Burr, the bridge builder. Oxford's location at the convergence of the Catskill-Ithaca Turnpike and Chenango Canal made it an ideal location for commerce. (Courtesy of the Oxford Historical Society.)

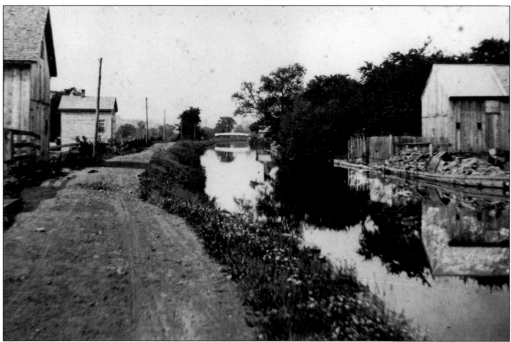

This is a view of the canal as it passed through Oxford on a slight curve. To the left of the towpath, one can see telegraph poles. The telegraph lines closely followed the canal route. (Courtesy of the Oxford Historical Society.)

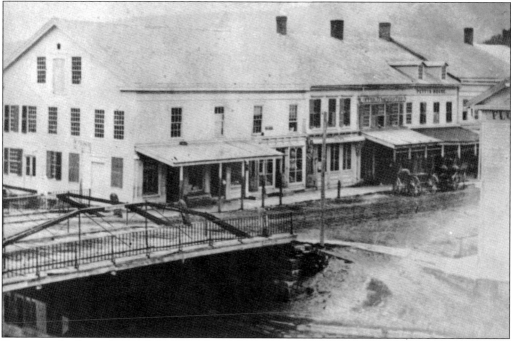

Businesses built on the banks of the Chenango Canal in Oxford. The convergence of the canal and the Catskill-Ithaca Turnpike in Oxford was ideal for commerce. (Courtesy of the Oxford Historical Society.)

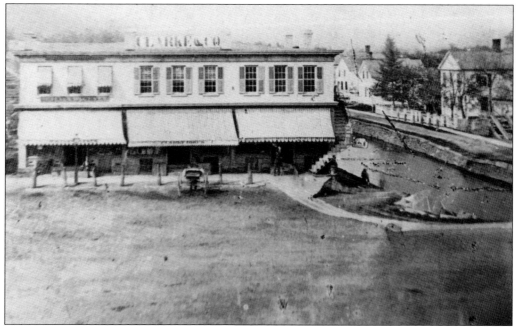

The canal collector's office was located in the Clarke Building. Toll collectors were located in Utica, Hamilton, Oxford, and Binghamton. Since there were no weigh stations on the Chenango Canal, collectors had to rely on the boats' bills of lading in assessing tolls. (Courtesy of the Oxford Historical Society.)

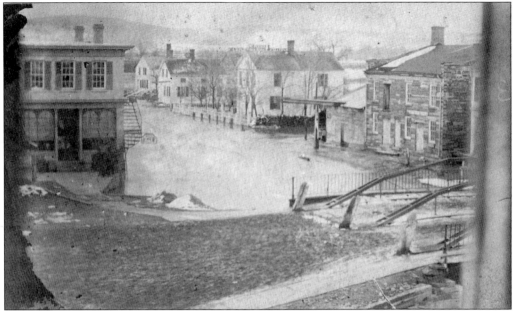

A problem for all New York canals was flooding caused by spring freshets. Here, a spring freshet floods the banks of the canal near the Clarke Building in Oxford, New York. (Courtesy of the Oxford Historical Society.)

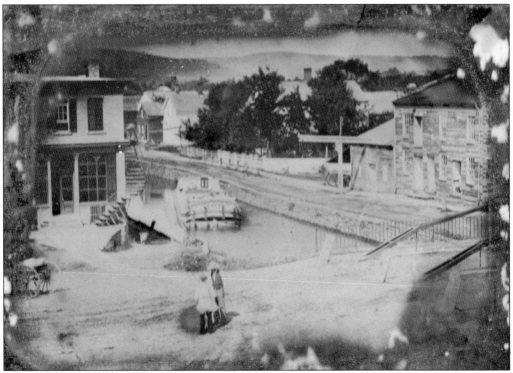

This rare daguerreotype shows a canalboat near the Clarke Building in Oxford, New York. Only a handful of photographs of Chenango canalboats exist. (Courtesy of the Oxford Historical Society.)

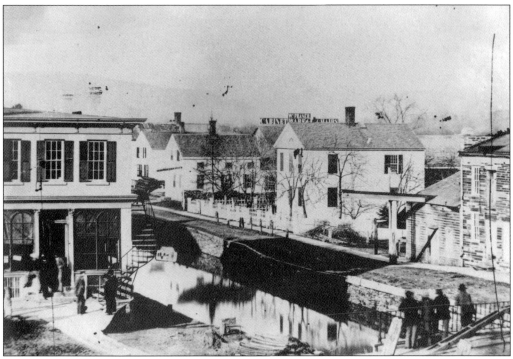

Onlookers await the passing of a packet boat. Note the advertisement for a cabinet and chair shop on the roof of a building in the background. (Courtesy of the Oxford Historical Society.)

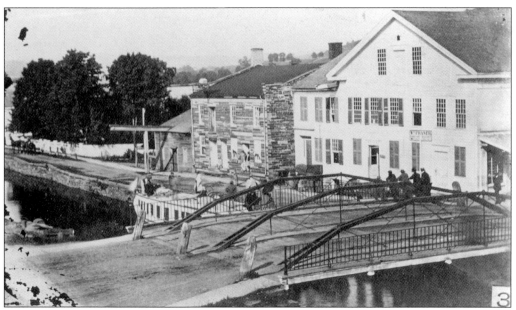

A packet boat passes under a bridge near the Clarke Building in Oxford. Packets provided daily service for travelers traveling from Norwich to Binghamton. (Courtesy of the Oxford Historical Society.)

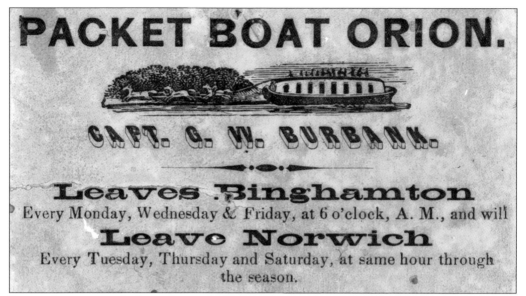

Due to the numerous locks on the northern part of the canal—76 in the first 23 miles—it was not practical to have packet boat service there as it was faster to walk. This was not the case on the southern end of the canal. Packet boat service was available between Norwich and Binghamton. (Courtesy of the Broome County Library.)

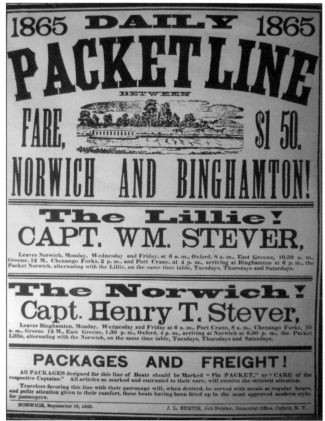

A September 16, 1865, advertisement details packet line service from Norwich to Binghamton with two boats: the *Lillie* and the *Norwich*. The fare for the journey was $1.50.

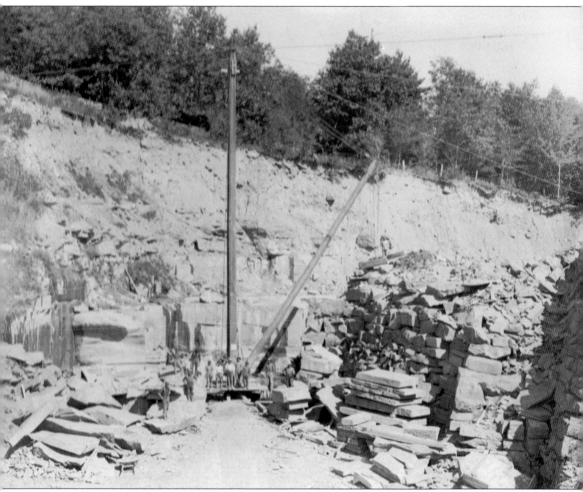

The Clarke Quarry shipped bluestone on canalboats to construction sites as far as New York City. Huge derricks moved the stone for transport. (Courtesy of the Oxford Historical Society.)

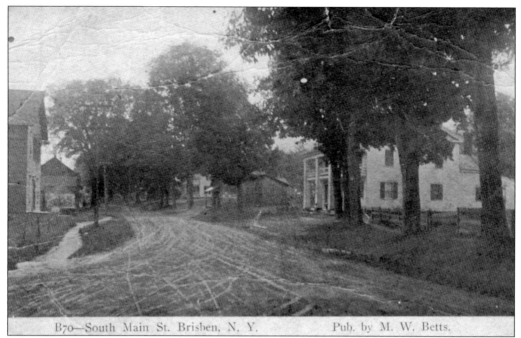

B70—South Main St. Brisben, N. Y. Pub. by M. W. Betts.

During the canal era, the village of Brisben was known as East Greene. It had boat repair shops and two hotels for canal travelers. (Courtesy of Paul and Mary King.)

In 1838, David Crandall utilized leftover canal stone materials to build the Stone House Tavern between Oxford and Greene for canal travelers. It has been said that the infamous Loomis Gang hid stolen horses in its cellar before moving them down the canal. (Courtesy of the Greene Historical Society.)

The canal passes through the village of Greene. A canalboat can be seen just pass the high-arching bridge. (Courtesy of Paul and Mary King.)

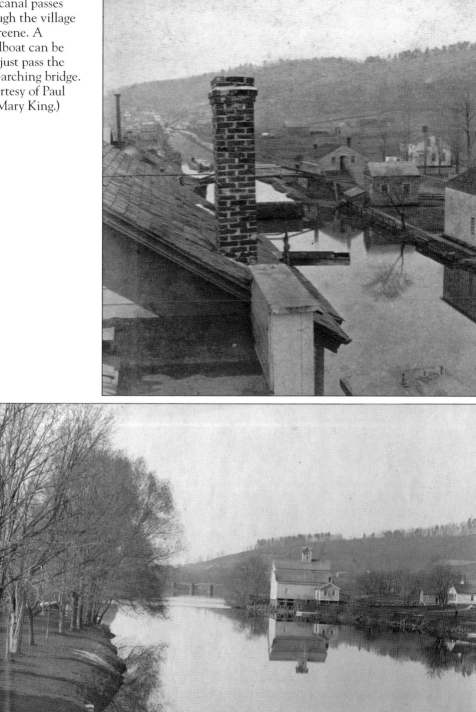

Traveling north on the Chenango River, boatmen approaching the town of Greene would see the massive aqueduct in the distance spanning the river. Large wooden piles are visible in the water near the white building on the right. (Courtesy of Paul and Mary King.)

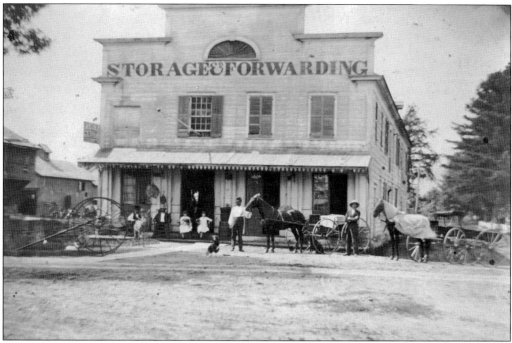

Like many of the communities along the canal, Greene was the home for storage and forwarding businesses. Potash and lumber were major products shipped from Greene. (Courtesy of the Greene Historical Society.)

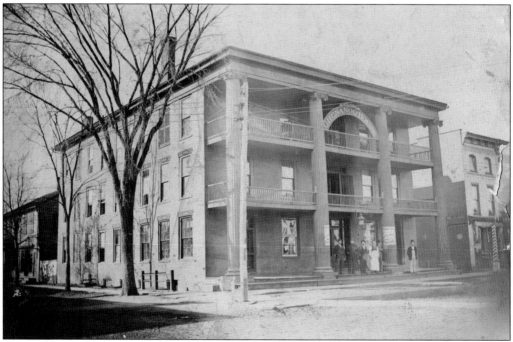

The Chenango House, built in 1838, accommodated canal travelers in Greene, New York. The hotel burned in 1865. The Sherwood Hotel would later be erected on the same site. (Courtesy of the Greene Historical Society.)

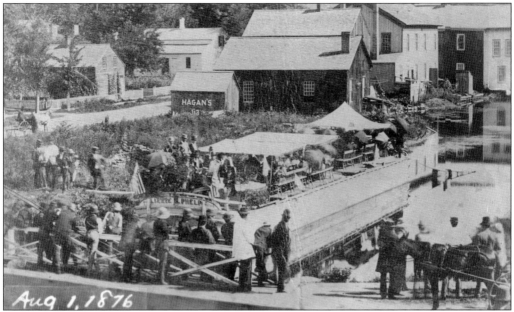

The coal boat *Lizzie Phelps* was converted to a party boat to take folks to a picnic in August 1876. In the foreground, men view the proceedings from the canal swing bridge in Greene. (Courtesy of the Greene Historical Society.)

This old postcard depicts the towpath as it approaches Binghamton, New York. The towpath was supposed to be 15 feet wide, but as the years went by, landowners started to encroach on it.

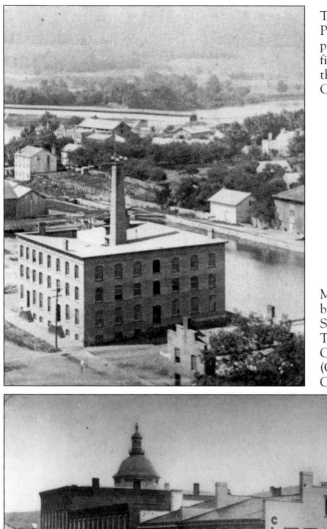

The Blanchard and Bartlett Planing Mill, located on the canal, processed rough lumber. The finished product was sent out on the canal. (Courtesy of the Broome County Historical Society.)

Many businesses line the canal bank in this view of the Court Street Bridge in Binghamton. The dome of the Broome County Courthouse is in the background. (Courtesy of the Broome County Historical Society.)

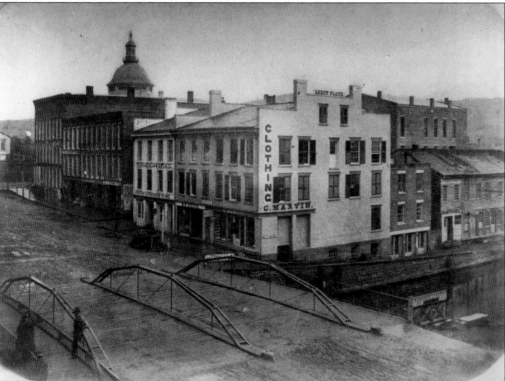

Five

THE DEMISE OF
THE CANAL

As the canal grew older, coal became the most important cargo transported. Men like Charles McKinney of Binghamton built their fortunes on the sale and delivery of coal. The major problem with the canal was that it did not reach the coalfields of Pennsylvania. Trains move the coal from the mines to Port Dickson, where canalboats picked it up and moved it up the canal. After the Civil War, more and more of the coal business was went directly to the rapidly advancing railroads that provided reliable year-round service. To counter this, advocates argued for a canal extension to the coalfields, as had originally been suggested in 1838. Work started on the proposed 30-mile extension in 1863; however, money ran out and the project was abandoned in 1867.

Along with the diminishing freight traffic, the canal became increasingly more expensive to maintain. Canal engineers, like Ogden Edwards, fought a losing battle to keep the canal running. Many canal workers, like Phillip Armour, were leaving the canal for other opportunities. Ironically, it was an invention of the canal's chief engineer, John B. Jervis, that eventually allowed the railroads to overtake the canals. By 1878, the canal was no longer viable, so it officially closed and its were assets sold.

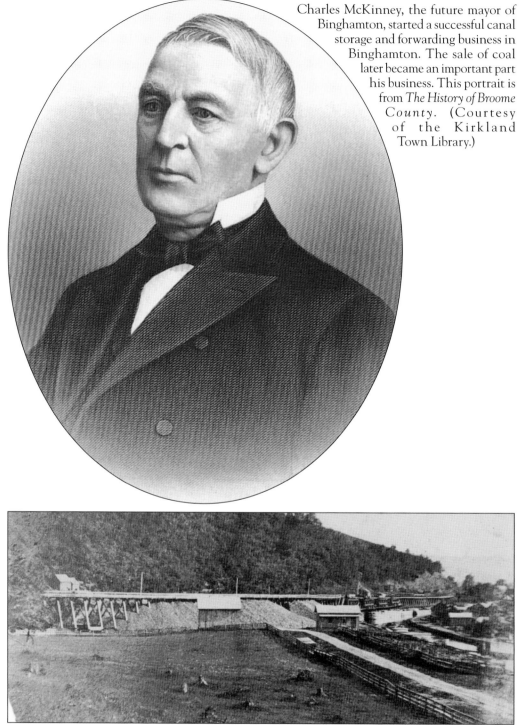

Charles McKinney, the future mayor of Binghamton, started a successful canal storage and forwarding business in Binghamton. The sale of coal later became an important part his business. This portrait is from *The History of Broome County*. (Courtesy of the Kirkland Town Library.)

The canal did not extend to the coalfields of Pennsylvania and coal thus had to be transported to a coal station in Port Dickinson for pickup by canalboats where the tracks of the Syracuse & Binghamton Railroad ran next to the canal. (Courtesy of the Broome County Historical Society.)

As early as 1838, an extension of the canal to the coalfields was proposed. Joseph Dana Allen, an engineer on the first Chenango Canal construction in 1834, was chosen to survey a route for the proposed canal extension. (Courtesy of Norwich University Archives.)

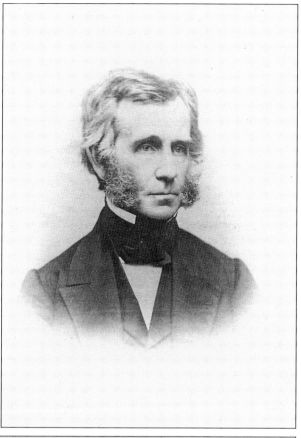

The Rock Bottom Dam on the Susquehanna River was to have been raised two feet to create enough slack water so canalboats could cross on the canal extension to the coalfields. (Courtesy of the Broome County Historical Society.)

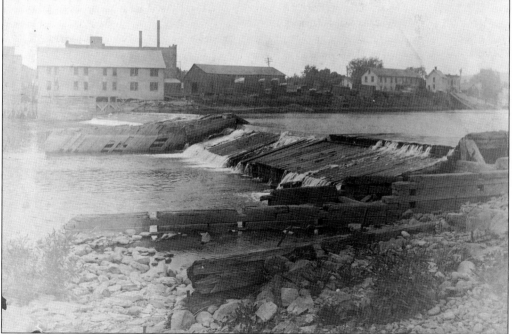

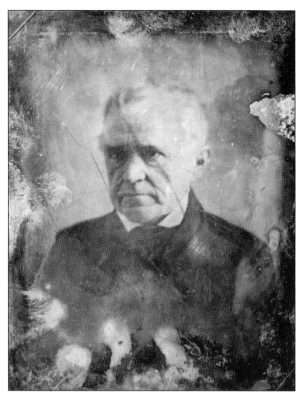

Appointed engineer of the canal in 1857, Ogden Edwards face the challenge of making many expensive repairs or replacement of locks and bridges due to weather or misuse. By 1878, the rapidly deteriorating canal was thought to be too expensive to continue operating. (Courtesy of the Library of Congress.)

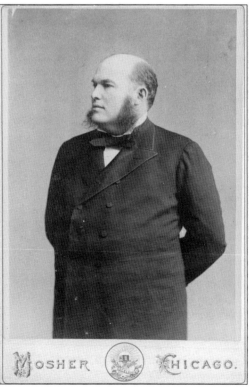

Phillip Armour, originally from Stockbridge, New York, was one of the most famous "hoggies" (mule driver) on the canal. He drove mule teams on the Chenango Canal in his youth. Like many men his age, he quickly left the canal for more promising prospects. He would later walk to California during the Gold Rush and later became famous for his meatpacking business in Chicago. (Courtesy of the Chicago History Museum.)

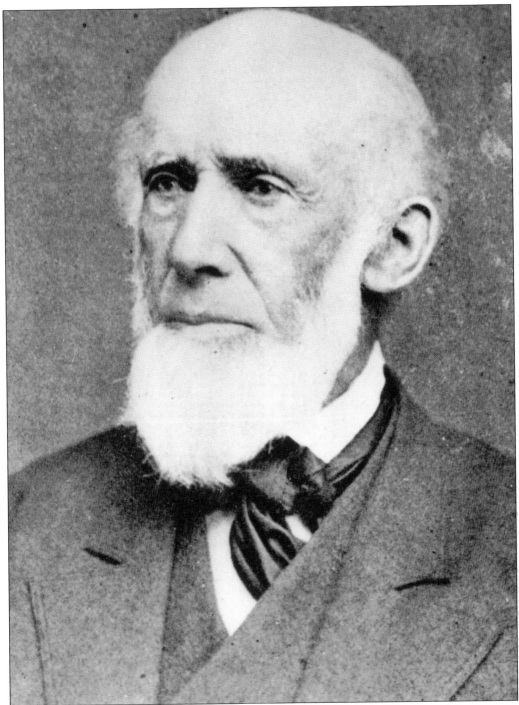

This is a portrait of John B. Jervis as he approached the end of his engineering career. His invention of the moveable forward truck design for locomotives in 1832 probably hastened the demise of the Chenango Canal. This design became the standard for all locomotives in the 1800s. It allowed trains to safely travel around curves and at high speed. Reliable year-round transportation sounded the death knell for canal transportation. (Courtesy of the Jervis Public Library.)

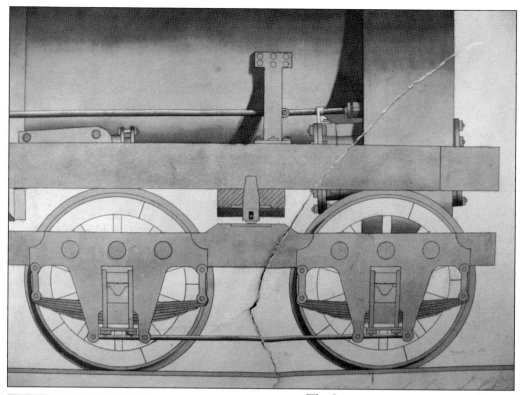

The Jervis invention was a set of four small wheels that pivoted on a single point. The arrangement allowed the wheels to follow the curve of the track without the risk of derailment. (Courtesy of the Jervis Public Library.)

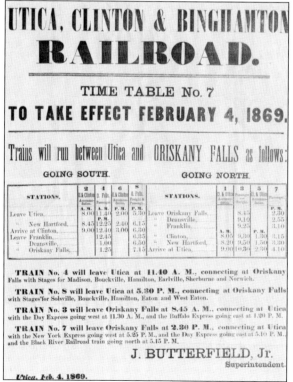

UTICA, CLINTON & BINGHAMTON RAILROAD.

TIME TABLE No. 7

TO TAKE EFFECT FEBRUARY 4, 1869.

Trains will run between Utica and ORISKANY FALLS as follows:

GOING SOUTH.

STATIONS.	2 B.& Clinton Accommodation.	4 O. Falls Passenger	6 B.& Clinton Accommodation.	8 O. Falls Freight & Passenger
	A.M.	A.M.	P.M.	P.M.
Leave Utica	8.00	11.40	2.00	5.30
" New Hartford	8.45	12.25	2.40	6.15
Arrive at Clinton	9.00	12.40	3.00	6.30
Leave Franklin		12.45		6.35
" Deansville		1.00		6.50
" Oriskany Falls		1.25		7.15

GOING NORTH.

STATIONS.	1 B.& Utica Accommodation. Freights.	3 Passenger	5 B.& Utica Accommodation. Freights.	7 Passenger
				P.M.
Leave Oriskany Falls		8.45		2.30
" Deansville		9.10		2.55
" Franklin		9.25		3.10
	A.M.		P.M.	
" Clinton	8.05	9.30	1.30	3.15
" New Hartford	8.20	9.50	1.50	3.30
Arrive at Utica	9.00	10.30	2.30	4.10

TRAIN No. 4 will leave Utica at 11.40 A. M., connecting at Oriskany Falls with Stages for Madison, Bouckville, Hamilton, Earlville, Sherburne and Norwich.

TRAIN No. 8 will leave Utica at 5.30 P. M., connecting at Oriskany Falls with Stages for Solsville, Bouckville, Hamilton, Eaton and West Eaton.

TRAIN No. 3 will leave Oriskany Falls at 8.45 A. M., connecting at Utica with the Day Express going west at 11.30 A. M., and the Buffalo Express going east at 1.20 P. M.

TRAIN No. 7 will leave Oriskany Falls at 2.30 P. M., connecting at Utica with the New York Express going west at 5.25 P. M., and the Day Express going east at 5.10 P. M., and the Black River Railroad train going north at 5.15 P. M.

J. BUTTERFIELD, Jr.
Superintendent.

Utica, Feb. 4, 1869.

After the Civil War, regular year-round train service was provided along much of the canal route. Canal service was limited from April to December. (Courtesy of John Taibi.)

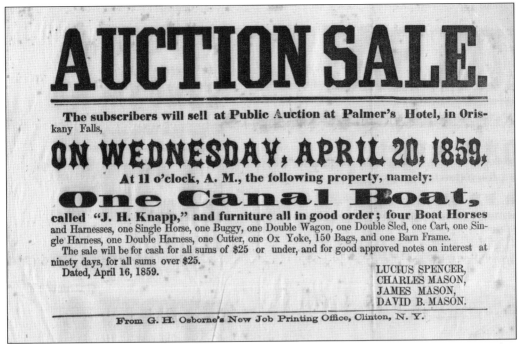

AUCTION SALE.

The subscribers will sell at Public Auction at Palmer's Hotel, in Oriskany Falls,

ON WEDNESDAY, APRIL 20, 1859,

At 11 o'clock, A. M., the following property, namely:

One Canal Boat,

called "J. H. Knapp," and furniture all in good order; four Boat Horses and Harnesses, one Single Horse, one Buggy, one Double Wagon, one Double Sled, one Cart, one Single Harness, one Double Harness, one Cutter, one Ox Yoke, 150 Bags, and one Barn Frame.

The sale will be for cash for all sums of $25 or under, and for good approved notes on interest at ninety days, for all sums over $25.

Dated, April 16, 1859.

LUCIUS SPENCER,
CHARLES MASON,
JAMES MASON,
DAVID B. MASON.

From G. H. Osborne's New Job Printing Office, Clinton, N. Y.

This canalboat advertisement for the sale of the *J.H. Knapp* on April 20, 1859, was typical as boating became less and less profitable. Owners looking to cut their losses sold out. (Courtesy of the Clinton Historical Society.)

The Hibbard and Alexander Forward and Storage canal building became the first railroad station in Clinton with the demise of the canal. It was replaced by a new train station in 1884. On the backside of the building, a flat bridge has replaced the Whipple bridge over the canal. Eventually, in this area, the canal was filled in and became Chenango Avenue. (Courtesy of the Clinton Historical Society.)

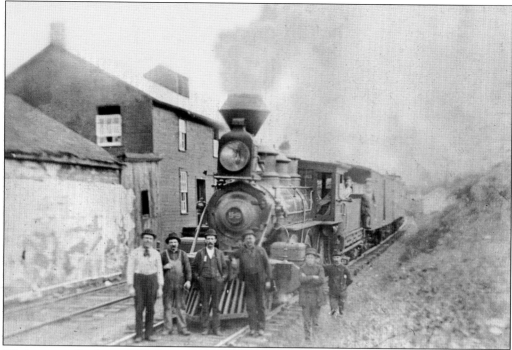

Workers pose for this c. 1870 photograph in front of the train in Deansboro, New York, mere yards from the canal. Unlike with the use of coal boats, coal could be delivered to its destination by train without time-consuming loading and unloading by manual labor. (Courtesy of John Taibi.)

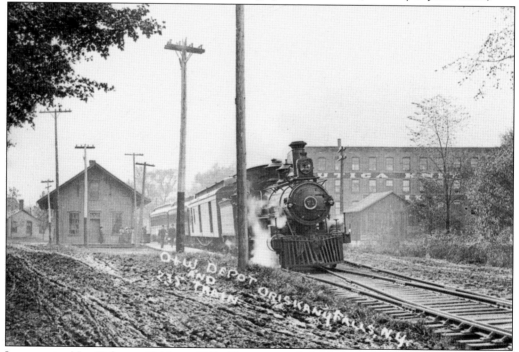

Locomotive No. 71 leaves Oriskany Falls. Trains provided reliable year-round transportation of freight and passengers. (Courtesy of John Taibi.)

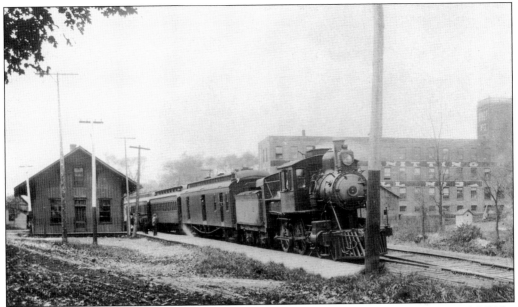

Locomotive No. 1 stops at the depot in Oriskany Falls, New York. The Utica Knitting Mill No. 3 is on the left. (Courtesy of John Taibi.)

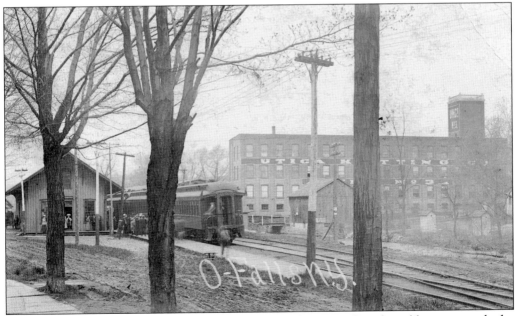

Passengers board the train in Oriskany Falls. The Chenango Canal could never match the passenger service or speed of trains. (Courtesy of John Taibi.)

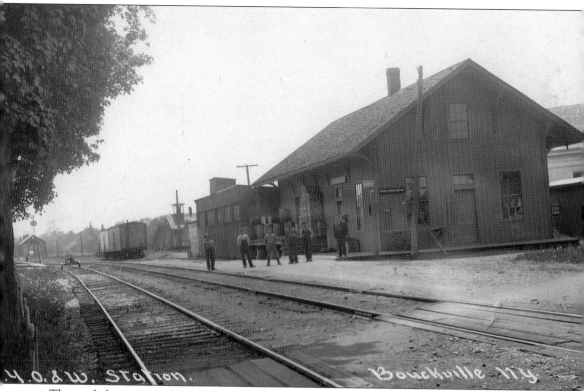

Y.O.&W. Station. Bouckville N.Y.

The apple businesses of Bouckville switched from canal transport to rail transportation to ship their products. The Bouckville Railroad depot began handling more and more freight with the decline of the canal. (Courtesy of the Town of Madison Historical Society.)

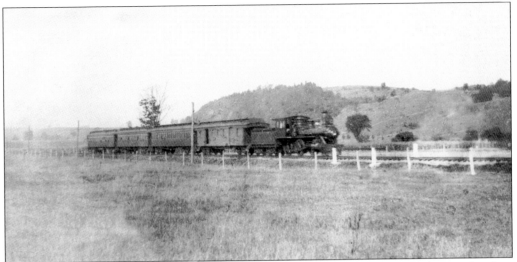

A train runs through the Pecksport area. As the trains took over cargo transport, the once-bustling Pecksport became a ghost town. (Courtesy of John Taibi.)

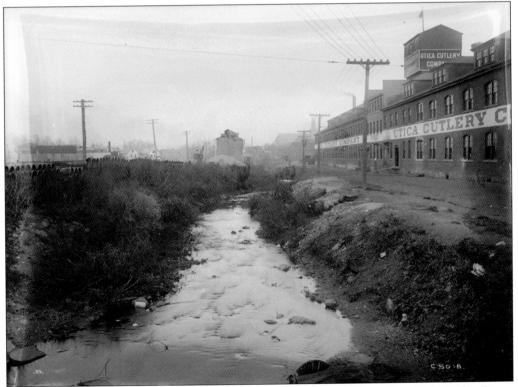

In 1918, canal water still flowed by the Utica Cutlery building in Utica, New York. Today, Route 12 runs over the filled-in canal. (Courtesy of Steamtown National Historic Site.)

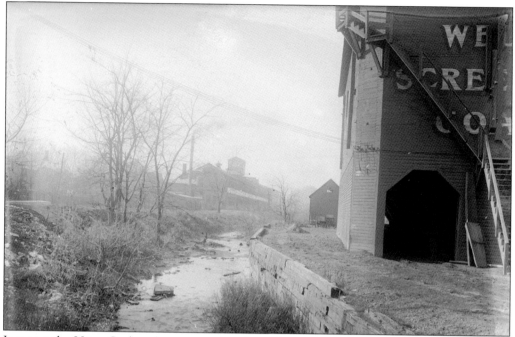

Just past the Utica Cutlery factory, an abandoned boat dock lies next to a coal business that once received its coal by boat. The railroad ran on the other side of the building. (Courtesy of Steamtown National Historic Site.)

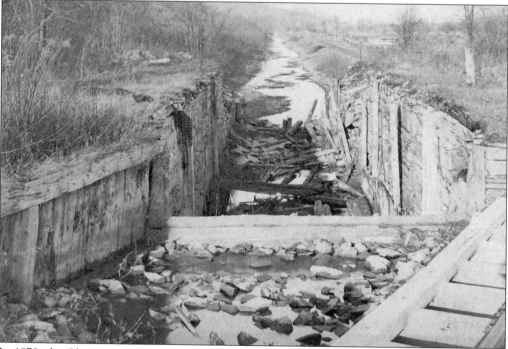

In 1878, the Chenango Canal officially closed. The canal was quickly scavenged for wood and stone. This photograph of the three-lock combine in Oriskany Falls shows its quick demise. (Courtesy of the Limestone Ridge Historical Society.)

With the canal abandoned, people were left on their own to deal with the empty ditch. Here, in Oriskany Falls, planks were laid over it. The canal was eventually filled in this area. Today, some lock stone protrudes from the ground in some backyards in Oriskany Falls. (Courtesy of the Limestone Ridge Historical Society.)

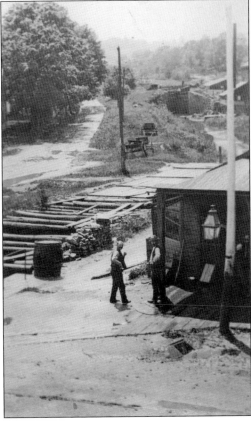

People raided the unused locks for their winter supply of firewood. What was not scavenged fell to rot. This lock near Oriskany Falls shows a lock gate half submerged in the lock chamber. (Courtesy of Waterville Historical Society.)

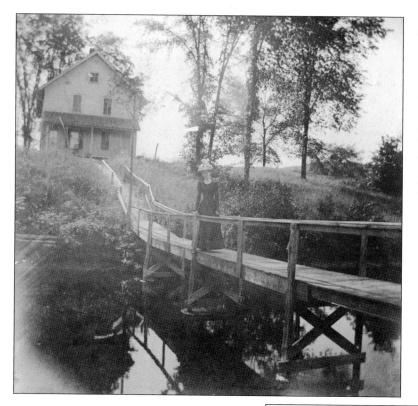

Jenney Fairchild stands on one of the many makeshift bridges over the canal. With no boat traffic, people made their own bridges where it was convenient. (Courtesy of Helen Nower.)

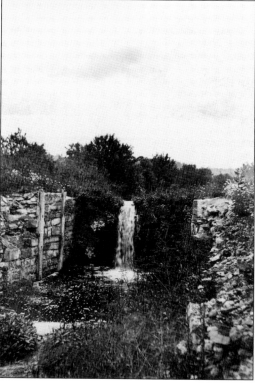

Water tumbles over an abandoned lock in Hamilton, New York. Many of its top stones have been removed. (Courtesy of the Hamilton Historical Commission.)

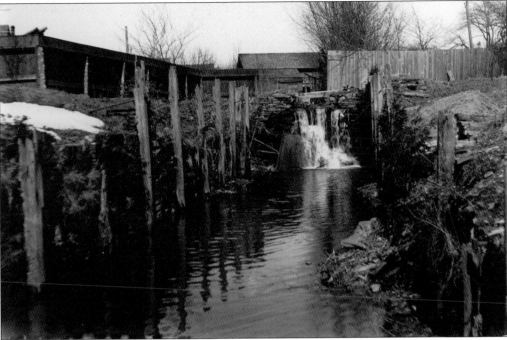

This lock has had many of its stones scavenged. The wooden fenders protrude from the lock walls, indicating that this lock had once been rebuilt on a new design. (Courtesy of the Hamilton Historical Commission.)

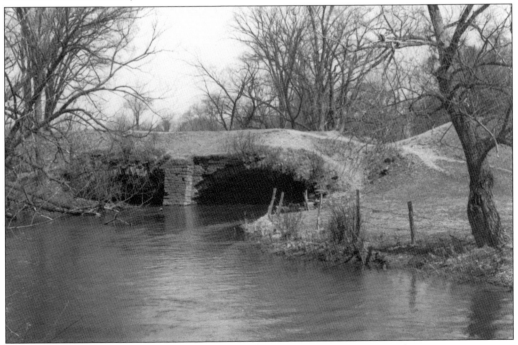

A source of amusement and curiosity, the Earlville Aqueduct attracted many visitors over the years. In the 1950s, he aqueduct was still intact but slowly eroding. (Courtesy of Quincy Square Museum.)

A pond known as "the Kershaw" was formed in the abandoned canal just outside Earlville. The banks of the former canal can be seen retaining the water. (Courtesy of Quincy Square Museum.)

Canal banks are visible just below the Kershaw pond and behind the Earlville Cemetery. Remnants of the canal can still be seen if one knows what to look for. (Courtesy of Quincy Square Museum.)

In Binghamton, the closed canal became an inconvenient ditch running through town. The stagnant water and trash deposited in it made the former canal an eyesore and health issue. (Courtesy of the Broome County Historical Society.)

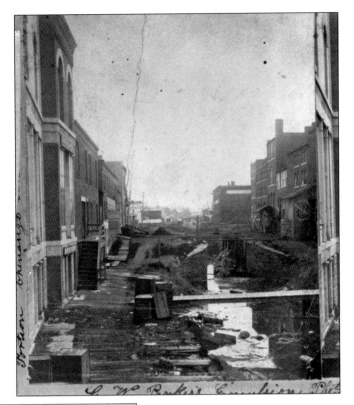

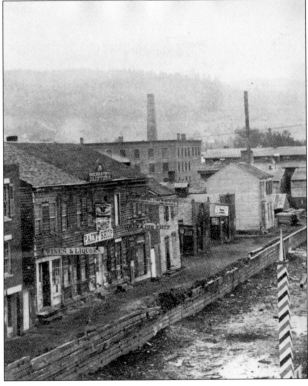

After the close of the canal, it became an eyesore to the people of Binghamton. The abandoned canal would soon be filled in and turned into State Street. (Courtesy of the Broome County Historical Society.)

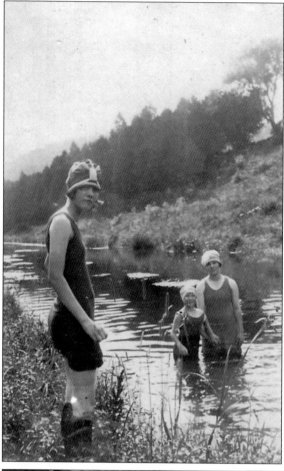

Ruth Edgarton Reynolds stands on the bank while her sisters Eleanor (left) and Elizabeth take a dip in the canal in 1926. Although no longer a commercial entity, the abandon canal still provided recreation for swimmers in the 1920s. (Courtesy of Gary Fuess.)

Children swim in the abandoned canal at the Edgarton Farm Bridge in 1926. Water still flows in the canal from the Bouckville to just above Solsville, where it empties into the Oriskany Creek. Eventually, the water reaches the Barge Canal. (Courtesy of Gary Fuess.)

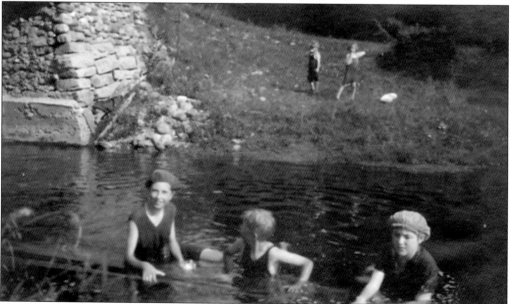

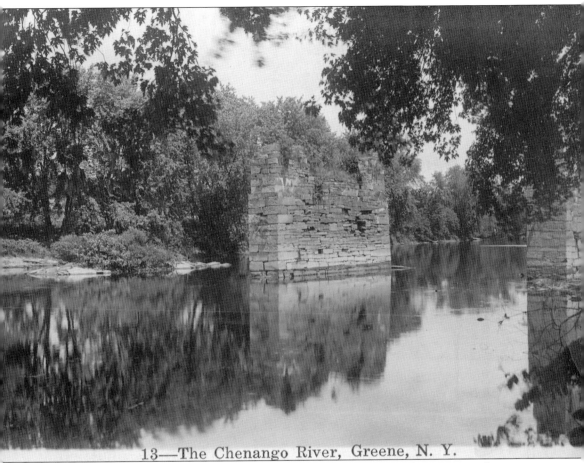

13—The Chenango River, Greene, N. Y.

All that remains of the Greene Aqueduct are the stone abatements and the stone pier that once held up the wooden trough. In this photograph, two towers still stand. Today, only one survives. (Courtesy of the Greene Historical Society.)

DISCOVER THOUSANDS OF LOCAL HISTORY BOOKS FEATURING MILLIONS OF VINTAGE IMAGES

Arcadia Publishing, the leading local history publisher in the United States, is committed to making history accessible and meaningful through publishing books that celebrate and preserve the heritage of America's people and places.

Find more books like this at
www.arcadiapublishing.com

Search for your hometown history, your old stomping grounds, and even your favorite sports team.

Consistent with our mission to preserve history on a local level, this book was printed in South Carolina on American-made paper and manufactured entirely in the United States. Products carrying the accredited Forest Stewardship Council (FSC) label are printed on 100 percent FSC-certified paper.

MADE IN THE USA